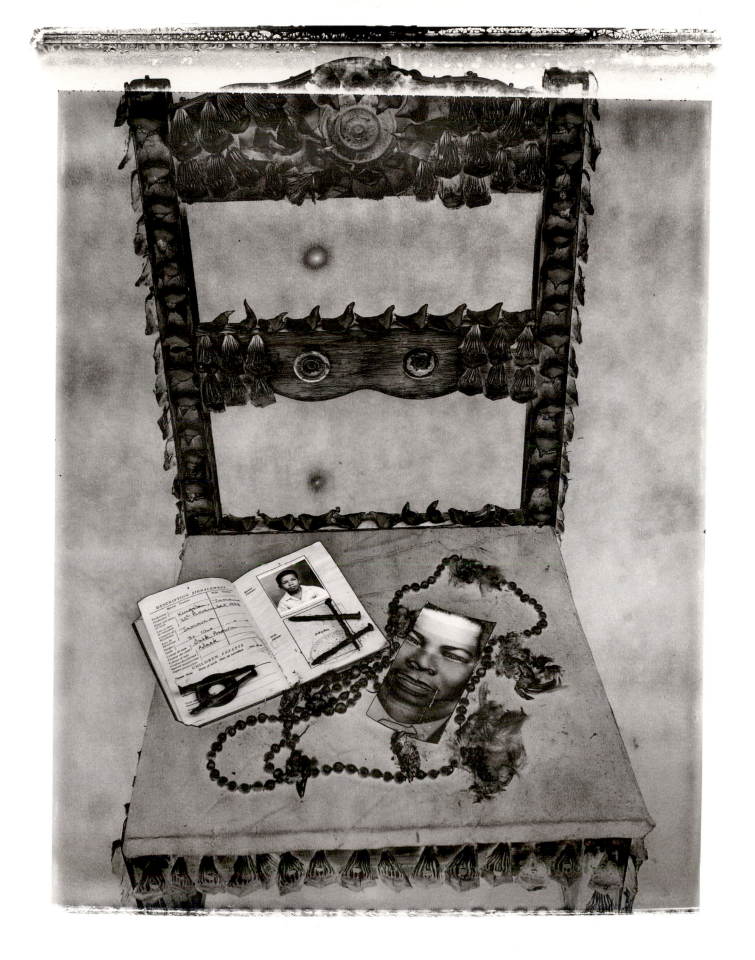

Tracing Cultures was first published by The Friends of Photography on the occasion of the three-part exhibition series POINTS OF ENTRY created by the Museum of Photographic Arts, San Diego; the Center for Creative Photography, Tucson; and The Friends of Photography, San Francisco.

Tracing Cultures was edited by Michael Read and Steven Jenkins

Michael Read, POINTS OF ENTRY
 Publication Coordinator
Rupert Jenkins, POINTS OF ENTRY
 Production Editor
Designed by Toki Design, San Francisco

©1995 by The Friends of Photography

Library of Congress Catalog Card Number 95-076803

ISBN 0-933286-69-4

All Rights Reserved.

Printed in Hong Kong by C & C Printing Co., Ltd.

Distributed by the University of New Mexico Press, Albuquerque

TRACING CULTURES

Albert Chong

Lewis deSoto

I.T.O.

Young Kim

Komar & Melamid

Dinh Q. Le

Gavin Lee

María Martínez-Cañas

Rubén Ortíz Torres

Carrie Mae Weems

Kim Yasuda

Introduction by Andy Grundberg
Essays by Rebecca Solnit and Ronald Takaki

Made possible by AT&T NEW ART/NEW VISIONS

The Friends of Photography

San Francisco

POINTS OF ENTRY has been made possible by a major grant from the Lila Wallace—Reader's Digest Fund

The entire POINTS OF ENTRY three-part exhibition series, catalogues, national tour, and educational programming has been made possible by a major grant from the

LILA WALLACE—READER'S DIGEST FUND

A Nation of Strangers

Reframing America

Tracing Cultures

Additional support for the national tour and promotion of POINTS OF ENTRY has been generously provided by ✳ **Metropolitan Life Foundation**

POINTS OF ENTRY National Tour

Museum of Photographic Arts
San Diego, California
September, 1995

Center for Creative Photography
Tucson, Arizona
September, 1995

The Friends of Photography/
Ansel Adams Center for Photography
San Francisco, California
September, 1995

International Museum of Photography
 at George Eastman House
Rochester, New York
April, 1996

National African American
 Museum Project
Smithsonian Institution
Washington, DC
August, 1996

High Museum of Art
Nexus Contemporary Art Center
Jimmy Carter Presidential
 Library-Museum
Atlanta, Georgia
February, 1997

Center for the Fine Arts
Miami, Florida
September, 1997

THIS CATALOGUE DOCUMENTS ONE OF THREE EXHIBITIONS that together constitute POINTS OF ENTRY, a unique collaboration among three photography museums intended to focus attention on one of the central defining issues of American life: immigration.

Photography can teach us a great deal about what immigration means within the context of American culture. For the past century and a half, photographers have documented the faces and experiences of those who immigrated to this country. Many of America's finest photographers have been immigrants themselves, and the work they produced in this country has expanded our artistic boundaries and deepened our understanding of the complexities and contradictions inherent to a nation of immigrants. And today, many younger artists are looking at the experience of immigration as a key to comprehending their own cultural heritages and identities.

As a series, POINTS OF ENTRY seeks to expand the discussion about the meanings and impact of immigration through photography. Some of those photographs are historical images found in archives across the country, some are among the classic works of art of the twentieth century, some have been created by a new generation of artists. Together they constitute a rich panorama of artistic responses to the subject of immigration and cultural differences.

To create such a complex and important project, three museums in three different communities joined together in a collaborative effort, supported by a major grant from the Lila Wallace–Reader's Digest Fund and with additional support from Metropolitan Life Foundation. The Museum of Photographic Arts (San Diego) initiated the collaboration and secured the project funding. The exhibitions, catalogues, and programming were created and produced in a partnership that involved the artistic and administrative staffs of the Museum of Photographic Arts, the Center for Creative Photography (Tucson), and The Friends of Photography (San Francisco).

We are profoundly grateful to the Lila Wallace–Reader's Digest Fund for its visionary grant, which enabled the consortium to take the risk to create POINTS OF ENTRY, and to Metropolitan Life Foundation, which stepped forward to support the national tour and its promotion at a crucial time in its development. Among the exceptional collaborators on the project have been Vicki Goldberg, guest curator for the Museum of Photographic Arts; Andrei Codrescu, Rebecca Solnit, and Ronald Takaki, guest essayists for the catalogues; and Catherine S. Herlihy, bibliographer. We thank them for their contributions, as we thank the literally hundreds of others across the country who provided support, guidance, advice, contacts, original art, and loans of historical materials.

The American public today is being exposed to a wide range of information and opinions about immigration and its impact on our culture. Many of the debates now taking place have roots that extend deep into American history. We hope that the efforts of the artists, scholars, writers, and researchers presented here will promote a fuller understanding of the richness of the American cultural experience, past, present, and future.

Andy Grundberg, Director, The Friends of Photography
Arthur Ollman, Director, Museum of Photographic Arts
Terence Pitts, Director, Center for Creative Photography

CONTENTS

BY ANDY GRUNDBERG

TRACING CULTURES is an exhibition of recent work by artists who employ photography to address issues of cross-cultural adjustment, displacement, and loss from the perspective of their own lives. While several of these artists are first- or second-generation immigrants to the United States, their work is not specifically about immigration, at least as that word is conventionally understood. Nor is it about what immigration "looks like" in the late twentieth century. Rather, it is about the simultaneously personal and political experience of cultural migration and cultural difference, and in particular the frequent conflict between one's culture of origin and an adopted American culture that, while in some respects hegemonic, is at root a medley of diverse, often contradictory cultural influences and impulses.

The idea of cultural migration and difference seems best suited to discussing the work of the artists in this exhibition because of the peculiar history of our national discourse about immigration. As we understand it today, immigration has meaning only in the context of governmental regulation of borders and population, but this was not always the case in the United States. In its first hundred years, our government was more concerned with the issue of citizenship than with immigration; until 1882, the United States had no laws that restricted the flow of immigrants to its shores. For much of our history, immigration was welcomed and encouraged. Only with federal regulation did immigration take on its current, politicized connotations of control, exclusion, and marginalization. Cultural migration as it is used here implies an experience that goes well beyond the crossing of national borders, having to do with a much more profound and long-lasting process of relocation of the very essence of one's community and identity.

Unlike many exhibitions that group artists together, *Tracing Cultures* is not intended to illustrate one curatorial thesis or master narrative. Instead, it reflects a faith that works of art, being products of their makers' intentions, speak for themselves. The twelve artists in the show, two of whom work as a team, take a variety of approaches to the subject of what it means to come from cultures outside of the United States and to confront what is, in effect, a complicated but well-enforced master narrative that defines who belongs here, who does not, and who decides. Their work reflects a widespread preoccupation with this topic within contemporary art; many more artists are working in this vein than could be included here.

The reasons that artists today are concentrating on the terms of their cultural identity and status within the larger culture of the United

States are not difficult to discern. As Ronald Takaki points out in his essay "A Different Mirror," demographic changes are causing us to reconsider what it means to be an American. No longer does the picture of a society made up of European descendants and "others" describe with any accuracy the texture of our increasingly diverse national makeup (in fact, it never did, given the history of Native and African Americans). One could argue that "otherness" is merely a construction created by those seeking

Many of the photographs in the exhibition are mementos of the existence of an earlier generation and, in some cases, evidence of the changes that have made the past irretrievable.

to form (or, more recently, to shore up) a simple, coherent version of our national identity. While the Other may be a necessary term in the definition of individual identity, in sociological terms it places artificial boundaries between us. The artists in this exhibition do not represent the Other in American life—or, for that matter, the Other in contemporary art. They do, however, represent a compelling current in the art of our day that embodies new aesthetic and critical concepts, new subject matter and new moral imperatives.

Photographs play a key role in the work of these artists because camera images are tokens of people, times, and places that cannot be recaptured except in terms of the photographic image. Many of the photographs in the exhibition are mementos of the existence of an earlier generation

and, in some cases, evidence of the changes that have made the past irretrievable. Memory, and the persistence of cultural heritage despite the intrusions of contemporary American popular culture, are subjects addressed implicitly and explicitly within the context of reusing family photographs from the past. Photographs also are used because they have the cultural status of witness: as testimony, they ground the work in a reality that is assertive, melancholy, nostalgic, and impassioned.

The exhibition includes artists of many backgrounds and cultural origins, but *Tracing Cultures* is not meant to be either a demographic catalogue or a representative sampling of artists working in the United States today. One might, however, think of the show as a survey of the many possible relationships to what has been called the immigrant experience. While it is fair to say that everyone in the United States comes from somewhere, the hows and whys of our arrival vary radically. The native people of Lewis deSoto's work, "Tahualtapa (Hill of the Ravens)," migrated across the Bering Strait thousands of years before the Spanish, French, Dutch, English, and other Europeans finally arrived on these shores. The Africans brought here in chains from slave ports like the one shown in Carrie Mae Weems's work were immigrants only in the most charitable construction of the term.

Even in the heyday of immigration from northern and southern Europe at the end of the nineteenth century, the experience of arrival was far from

uniform. Ships sailing into New York harbor disgorged their first- and second- class passengers directly onto Manhattan Island; only steerage or third-class passengers were then ferried to Ellis Island to pass the rigorous inspections for admission to the United States. But, as Rebecca Solnit suggests here in a poetic and profound meditation on her own family's past, memories of where we come from and how we got to these shores can be as much a fabrication as the myth of the melting pot itself.

Artists like Albert Chong, Young Kim, Dinh Q. Le, Komar & Melamid, and María Martínez-Cañas have experienced firsthand the enduring fracture of moving from the countries in which they were born to this one. Gavin Lee and Kim Yasuda are among an even larger number of artists today whose work tries to come to terms with the decisive cultural journeys of their parents, grandparents, or more distant ancestors. And I.T.O. (whose given name is Shigeki Ito) and Rubén Ortíz Torres bring to the show the perspective of visitors who, in an increasingly frequent pattern, cross borders as readily as their work is able to cross cultures. Like all the artists in the show, they draw artistic power by foregrounding their status as cultural migrants.

That cultural migration, diversity, and displacement have become powerful and popular subjects for contemporary artists using photography is hardly surprising; what *is* surprising, however, is how new this work seems in the context of photography's

artistic, commercial, and vernacular functions of the past 100 years. Images through which immigrants to this country addressed their complex, reformed identities (and, one imagines, their marginalized existence as so-called hyphenated Americans) were undoubtedly made, but such photographs have by and large been hidden away in thousands and thousands of family albums passed on from one generation to the next. And photographers seeking to make art did not, until recently, make their own cultural backgrounds the dominant theme of their work.

One likely reason for this lacuna in photography's broad panorama of American life is that for many years there was a widely held belief in the virtue of fitting in; images that classified one as exotic and alien were not tickets to artistic or even material success. At the same time, photography seems to have been harnessed to the task of documenting the many cultures that constitute American culture only in moments of severe political controversy and strife. Lewis Hine photographed new arrivals on Ellis Island, for example, in the context of widespread anger over the economic impact of immigrant labor, and not merely because of an abstract admiration for their inherent dignity. Similarly, the many photographers working today along the border between Mexico and the United States may be motivated by principle, but their work gets its meaning from the politics of immigration in our own historical moment.

Photography often has been called a "universal language," capable of transcending differences of language and of culture. Like anthropology and ethnography, it was thought to have its roots in a scientific, empirical point of view that gave it universal credence. But photography's claim to represent other cultures impartially and fairly is no more accepted today than that of the social sciences; the notion of observation and description outside of culture has been discredited in both theory and practice. This perhaps explains why the artists in *Tracing Cultures* insist on contextualizing the photographic image by fragmenting it, displacing it, and juxtaposing it with painted, sculptural, and other materials—all in the name of a kind of Brechtian awareness of its conventionally-framed meanings. Photography, in their work, is less authoritative and more amenable to individual, idiosyncratic meaning.

What remains for us today is the belief that photography, in the right hands, can speak not only for those descended from the European culture that developed Renaissance perspective and invented the camera, but also for those who, for much of the medium's history, were consigned to be its subjects. Now, at a time in which cultural identity is being challenged by yet another great universalizer, the computer, the subject of the camera has fundamentally changed. *Tracing Cultures* is about a photography in which subjectivity has replaced subjecthood, and in which the power of representation ultimately rests with those who are represented. ◀

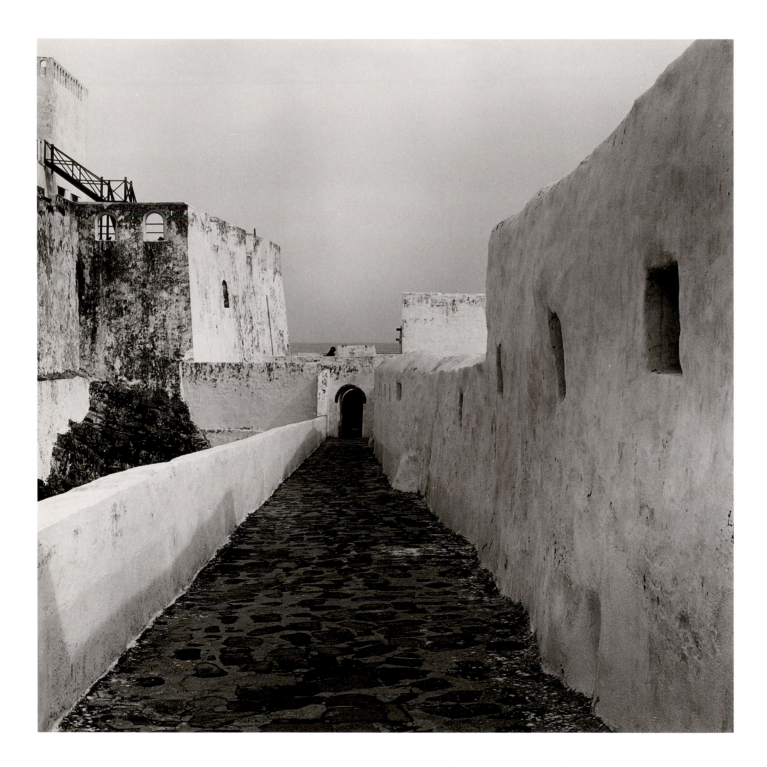

I HAD FLOWN FROM SAN FRANCISCO to Norfolk and was riding in a taxi to my hotel to attend a conference on multiculturalism. Hundreds of educators from across the country were meeting to discuss the need for greater cultural diversity in the curriculum. My driver and I chatted about the weather and tourists. The sky was cloudy, and Virginia Beach was twenty minutes away. The rearview mirror reflected a white man in his forties. "How long have you been in this country?" he asked. "All my life," I replied, wincing. "I was born in the United States." With a strong southern drawl, he remarked: " I was wondering because your English is excellent!" Then, as I had many times before, I explained: " My grandfather came here from Japan in the 1880s. My family has been here, in America, for over a hundred years." He glanced at me in the mirror. Somehow I did not look "American" to him; my eyes and complexion looked foreign.

Suddenly, we both became uncomfortably conscious of a racial divide separating us. An awkward silence turned my gaze from the mirror to

the passing landscape, the shore where the English and the Powhatan Indians first encountered each other. Our highway was on land that Sir Walter Raleigh had renamed "Virginia" in honor of Elizabeth I, the Virgin Queen. In the English cultural appropriation of America, the indigenous peoples themselves would become outsiders in their native land. Here, at the eastern edge of the continent, I mused, was the site of the beginning of multicultural America. Jamestown, the English settlement founded in 1607, was nearby: the first twenty Africans were brought here a year before the Pilgrims arrived at Plymouth Rock. Several hundred miles offshore was Bermuda, the "Bermoothes" where William Shakespeare's Prospero had landed and met the native Caliban in *The Tempest*. Earlier, another voyager had made an Atlantic crossing and unexpectedly bumped into some islands to the south. Thinking he had reached Asia, Christopher Columbus mistakenly identified one of the islands as "Cipango" (Japan). In the wake of the admiral, many peoples would come to America from different shores, not

BY RONALD TAKAKI

Carrie Mae Weems, Untitled, from the series *Africa*, 1993. Gelatin silver print, 20 by 20 in. Courtesy of the artist and P.P.O.W., New York

only from Europe but also Africa and Asia. One of them would be my grandfather. My mental wandering across terrain and time ended abruptly as we arrived at my destination. I said goodbye to my driver and went into the hotel, carrying a vivid reminder of why I was attending this conference.

QUESTIONS LIKE THE ONE MY TAXI DRIVER asked me are always jarring, but I understand why he could not see me as an American. He had a narrow but widely-shared sense of the past—a history that has viewed American as European in ancestry. "Race," Toni

MORE THAN EVER BEFORE, AS WE APPROACH THE TIME WHEN WHITES BECOME A MINORITY, MANY OF US ARE PERPLEXED ABOUT OUR NATIONAL IDENTITY AND OUR FUTURE AS ONE PEOPLE.

Morrison explained, has functioned as a "metaphor" necessary to the "construction of Americanness": in the creation of our national identity, "American" has been defined as "white."[1]

But America has been racially diverse since our very beginning on the Virginia shore, and this reality is increasingly becoming visible and ubiquitous. Currently, one-third of the American people do not trace their origins to Europe; in California, minorities are fast becoming a majority. They already predominate in major cities across the country—New York, Chicago, Atlanta, Detroit, Philadelphia, San Francisco, and Los Angeles.

This emerging demographic diversity has raised fundamental questions about America's identity and culture.

In 1990, *Time* published a cover story on "America's Changing Colors." "Someday soon," the magazine announced, "white Americans will become a minority group." How soon? By 2056, most Americans will trace their descent to "Africa, Asia, the Hispanic world, the Pacific Islands, Arabia—almost anywhere but white Europe." This dramatic change in our nation's ethnic composition is altering the way we think about ourselves. "The deeper significance of America's becoming a majority nonwhite society is what it means to the national psyche, to individuals' sense of themselves and their nation—their idea of what it is to be American."[2]

Indeed, more than ever before, as we approach the time when whites become a minority, many of us are perplexed about our national identity and our future as one people. This uncertainty has provoked Allan Bloom to reaffirm the preeminence of Western civilization. The author of *The Closing of the American Mind*, he has emerged as a leader of an intellectual backlash against cultural diversity. In his view, students entering the university are "uncivilized," and the university has the responsibility to "civilize" them. Bloom claims he knows what their "hungers" are and "what they can digest." Eating is one of his favorite metaphors. Noting the "large black presence" in major universities, he laments the "one failure" in race relations—black students have proven to be "indigestible." They do not "melt as have *all* other groups." The problem, he contends, is that "blacks have become blacks": they have become

"ethnic." This separatism has been reinforced by an academic permissiveness that has befouled the curriculum with "Black Studies" along with "Learn Another Culture." The only solution, Bloom insists, is "the good old Great Books approach."[3]

Similarly, E. D. Hirsch worries that America is becoming a "Tower of Babel," and that this multiplicity of cultures is threatening to rend our social fabric. He, too, longs for a more cohesive culture and a more homogeneous America: "If we *had* to make a choice between the *one* and the *many*, most Americans would choose the principle of unity, since we cannot function as a nation without it." The way to correct this fragmentization, Hirsch argues, is to acculturate "disadvantaged children." What do they need to know? "Only by accumulating shared symbols, and the shared information that symbols represent," Hirsch answers, "can we learn to communicate effectively with one another in our national community." Though he concedes the value of multicultural education, he quickly dismisses it by insisting that it "should not be allowed to supplant or interfere with our schools' responsibility to ensure our children's mastery of American literate culture." In *Cultural Literacy: What Every American Needs to Know*, Hirsch offers a long list of terms that excludes much of the history of minority groups.[4]

While Bloom and Hirsch are reacting defensively to what they regard as a vexatious balkanization of America, many other educators are responding to our diversity as an opportunity to open American minds. In 1990, the Task Force on Minorities for New York emphasized the importance of a culturally diverse education. "Essentially," the *New York Times* commented, "the issue is how to deal with both dimensions of the nation's motto: '*E pluribus unum*'—'Out of many, one.'" Universities from New Hampshire to Berkeley have established American cultural diversity graduation requirements. "Every student needs to know," explained University of Wisconsin's chancellor Donna Shalala, "much more about the origins and history of the particular cultures which, as Americans, we will encounter during our lives." Even the University of Minnesota, located in a state that is 98 percent white, requires its students to take ethnic studies courses. Asked why multiculturalism is so important, Dean Fred Lukermann answered: As a national university, Minnesota has to offer a national curriculum—one that includes all of the peoples of America. He added that after graduation, many students move to cities like Chicago and Los Angeles and thus need to know about racial diversity. Moreover, many educators stress, multiculturalism has an intellectual purpose. By allowing us to see events from the viewpoints of different groups, a multicultural curriculum enables us to reach toward a more comprehensive understanding of American history.[5]

What is fueling this debate over our national identity and the content of our curriculum is America's intensifying racial crisis. The alarming signs and symptoms seem to be everywhere—the killing of Vincent Chin in Detroit, the black boycott of a Korean grocery store in Flatbush, the hysteria in Boston over the Carol Stuart murder, the battle between white sportsmen and Indians over tribal fishing rights in Wisconsin, the Jewish-black clashes in Brooklyn's Crown Heights, the black-Hispanic competition for jobs and educational resources in Dallas, which *Newsweek* described as "a conflict of the have-nots," and the Willie Horton campaign commercials, which widened the divide between the suburbs and the inner cities.[6]

This reality of racial tension rudely awoke America like a firebell-in-the-night on April 29, 1992. Immediately after four Los Angeles police officers were found not guilty of brutality against Rodney King, rage exploded in Los Angeles. Race relations reached a new nadir. During the nightmarish rampage, scores of people were killed, over two thousand injured, twelve thousand arrested, and almost a billion dollars' worth of property destroyed. The live televised images mesmerized America. The rioting and the murderous melee on the streets resembled the fighting in Beirut and the West Bank. The thousands of fires burning out of control and the dark smoke filling the skies brought back images of the burning oil fields of Kuwait during Desert Storm. Entire sections of Los Angeles looked like a bombed city. "Is this America?" many shocked viewers asked. "Please, can we get along here," pleaded Rodney King, calling for calm. "We all can get along. I mean, we're all stuck here for a while. Let's try to work it out."[7]

But how should "we" be defined? Who are the people "stuck here" in America? One of the lessons of the Los Angeles explosion is the recognition of the fact that we are a multiracial society and that race can no longer be defined in the binary terms of white and black. "We" will have to include Hispanics and Asians. While blacks currently constitute 13 percent of the Los Angeles population, Hispanics represent 40 percent. The 1990 census revealed that South Central Los Angeles, which was predominantly black in 1965 when the Watts rebellion occurred, is now 45 percent Hispanic. A majority of the first 5,438 people arrested were Hispanic, while 37 percent were black. Of the fifty-eight people who died in the riot, more than a third were Hispanic, and about 40 percent of the businesses destroyed were Hispanic-owned. Most of the other shops and stores were Korean-owned. The dreams of many Korean immigrants went up in smoke during the riot: two thousand Korean-owned businesses were damaged or demolished, totaling about $400 million in losses. There is evidence indicating they were targeted. "After all," explained a black gang member, "we didn't burn our community, just *their* stores."[8]

"I don't feel like I'm in America anymore," said Denisse Bustamente as she watched the police protecting the firefighters. "I feel like I am far away." Indeed, Americans have been witnessing ethnic strife erupting around the world—the rise of neo-Nazism and the murder of Turks in Germany, the ugly "ethnic cleansing"

in Bosnia, the terrible and bloody clashes between Muslims and Hindus in India. Is the situation here different, we have been nervously wondering, or do ethnic conflicts elsewhere represent a prologue for America? What is the nature of malevolence? Is there a deep, perhaps primordial, need for group identity rooted in hatred for the other? Is ethnic pluralism possible for America? But answers have been limited. Television reports have been little more than thirty-second sound bites. Newspaper articles have been mostly superficial descriptions of racial antagonisms and the current urban malaise. What is lacking is historical context; consequently, we are left feeling bewildered.[9]

How did we get to this point, Americans everywhere are anxiously asking. What does our diversity mean, and where is it leading us? How do we work it out in the post-Rodney King era?

Certainly one crucial way is for our society's various ethnic groups to develop a greater understanding of each other. For example, how can African Americans and Korean Americans work it out unless they learn about each other's cultures, histories, and also economic situations? This need to share knowledge about our ethnic diversity has acquired new importance, and has given new urgency to the pursuit for a more accurate history.

More than ever before, there is a growing realization that the established scholarship has tended to define America too narrowly. For example, in his prize-winning study

The Uprooted, Harvard historian Oscar Handlin presented—to use the book's subtitle—"the Epic Story of the Great Migrations That Made the American People." But Handlin's "epic story" excluded the "uprooted" from Africa, Asia, and Latin America—the other "Great Migrations" that also helped to make "the American People." Similarly, in *The Age of Jackson*, Arthur M. Schlesinger, Jr., left out blacks and Indians. There is not even a mention of two marker events—the Nat Turner insurrection and Indian removal. Andrew Jackson himself would have been surprised to find these omitted from a history of his era.[10]

Still, Schlesinger and Handlin offered us a refreshing revisionism, paving the way for the study of common people rather than of princes and presidents. They inspired the next generation of historians to examine groups such as the artisan laborers of Philadelphia and the Irish immigrants of Boston. "Once I thought to write a history of the immigrants in America," Handlin confided in his introduction to *The Uprooted*. "I discovered that the immigrants *were* American history." This door, once opened, led to the flowering of a more inclusive scholarship as we began to recognize that ethnic history was American history. Suddenly, there was a proliferation of seminal works such as Irving Howe's *World of Our Fathers: The Journey of the East European Jews to America*, Dee Brown's *Bury My Heart at Wounded Knee: An Indian History of the American West*, Albert Camarillo's *Chicanos in a Changing Society*, Lawrence Levine's *Black Culture and Black Con-*

sciousness, Yuji Ichioka's *The Issei: The World of the First Generation Japanese Immigrants*, and Kerby Miller's *Emigrants and Exiles: Ireland and the Irish Exodus to North America*.[11]

But even this new scholarship, while it has given us a more expanded understanding of the mosaic called America, does not address our needs in the post-Rodney King era. These books and others like them fragment American society, studying each group separately, in isolation from the other groups and the whole. While scrutinizing our specific pieces, we have to step back in order to see the rich and complex portrait they compose. What is needed is a fresh angle, a study of the American past from a comparative perspective.

AFRICAN AMERICANS have been the central minority throughout our country's history. They were initially brought here on a slave ship in 1619. Actually, these first twenty Africans might not have been slaves; rather, like most of the white laborers, they were probably indentured servants. The transformation of Africans into slaves is the story of the "hidden" origins of slavery. How and when was it decided to institute a system of bonded black labor? What happened, while freighted with racial significance, was actually conditioned by class conflicts within white society. Once established, the "peculiar institution" would have consequences for centuries to come. During the nineteenth century, the political storm over slavery almost destroyed the nation. Since the Civil War and eman-

cipation, race has continued to be largely defined in relation to African Americans—segregation, civil rights, the underclass, and affirmative action. Constituting the largest minority group in our society, they have been at the cutting edge of the Civil Rights Movement. Indeed, their struggle has been a constant reminder of America's moral vision as a country committed to the principle of liberty. Martin Luther King clearly understood this truth when he wrote from a jail cell: "We will reach the goal of freedom in Birmingham and all over the nation,

WHAT DOES OUR DIVERSITY MEAN, AND WHERE IS IT LEADING US? HOW DO WE WORK IT OUT IN THE POST-RODNEY KING ERA?

because the goal of America is freedom. Abused and scorned though we may be, our destiny is tied up with America's destiny."[12]

Asian Americans have been here for over one hundred and fifty years, before many European immigrant groups. But as "strangers" coming from a "different shore," they have been stereotyped as "heathen," exotic, and unassimilable. Seeking "Gold Mountain," the Chinese arrived first, and what happened to them influenced the reception of the Japanese, Koreans, Filipinos, and Asian Indians as well as the Southeast Asian refugees like the Vietnamese and the Hmong. The 1882 Chinese Exclusion Act was the first law that prohibited the entry of immigrants on the basis of nationality. The Chinese condemned this restriction as racist and tyrannical. "They call us 'Chink,'"

complained a Chinese immigrant, cursing the "white demons." "They think we no good! America cuts us off. No more come now, too bad!" This precedent later provided a basis for the restriction of European immigrant groups such as Italians, Russians, Poles, and Greeks. The Japanese painfully discovered that their accomplishments in America did not lead to acceptance, for during World War II, unlike Italian Americans and German Americans, they were placed in internment camps. Two-thirds of them were citizens by birth. "How could I, as a 6-month-old

THE ENCOUNTERS BETWEEN INDIANS AND WHITES NOT ONLY SHAPED THE COURSE OF RACE RELATIONS, BUT ALSO INFLUENCED THE VERY CULTURE AND IDENTITY OF THE GENERAL SOCIETY.

child born in this country," asked Congressman Robert Matsui years later, "be declared by my own Government to be an enemy alien?" Today, Asian Americans represent the fastest-growing ethnic group. They have also become the focus of much mass-media attention as "the Model Minority," not only in relation to blacks and Chicanos, but also to whites on welfare and even middle-class whites experiencing economic difficulties.[13]

Chicanos represent the largest group among the Hispanic population, which is projected to outnumber African Americans by the early twenty-first century. They have been in the United States for a long time, initially incorporated by the war against Mexico. The Treaty of Guadalupe-Hidalgo

of 1848 had moved the border between the two countries, and the people of "occupied" Mexico suddenly found themselves "foreigners" in their "native land." As historian Albert Camarillo pointed out, the Chicano past is an integral part of America's westward expansion, also known as "manifest destiny." But while the early Chicanos were a colonized people, most of them today have immigrant roots. Many began the trek to *El Norte* in the early twentieth century. "As I had heard a lot about the United States," Jesus Garza recalled, "it was my dream to come here." "We came to know families from Chihuahua, Sonora, Jalisco, and Durango," stated Ernesto Galarrza. "Like ourselves, our Mexican neighbors had come this far moving step by step, working and waiting, as if they were feeling their way up a ladder." Nevertheless, the Chicano experience has been unique, for most of them have lived close to their homeland—a proximity that has helped reinforce their language, identity, and culture. This migration to El Norte has continued to the present. Los Angeles has more people of Mexican origin than any other city in the world, except Mexico City. A mostly mestizo people of Indian as well as African and Spanish ancestries, Chicanos currently represent the largest minority group in the Southwest, where they have been visibly transforming culture and society.[14]

The Irish came here in greater numbers than most immigrant groups. Their history has been tied to America's past from the very beginning. Ireland represented the earliest Eng-

lish frontier: the conquest of Ireland occurred before the colonization of America, and the Irish were the first group that the English called "savages." In this context, the Irish past foreshadowed the Indian future. During the nineteenth century, the Irish, like the Chinese, were victims of British colonialism. While the Chinese fled from the ravages of the Opium Wars, the Irish were pushed from their homeland by "English tyranny." Here, they became construction workers and factory operatives as well as the "maids" of America. Representing a Catholic group seeking to settle in a fiercely Protestant society, the Irish immigrants were targets of American nativist hostility. They were also what historian Lawrence J. McCaffrey called "the pioneers of the American urban ghetto," "previewing" experiences that would later be shared by the Italians, Poles, and other groups from southern and eastern Europe. Furthermore, they offer contrast to the immigrants from Asia. The Irish came about the same time as the Chinese, but they had a distinct advantage: the Naturalization Law of 1790 had reserved citizenship for "whites" only. Their compatible complexion allowed them to assimilate by blending into American society. In making their journey successfully into the mainstream, however, these immigrants from Erin pursued an Irish "ethnic" strategy: they promoted "Irish" solidarity in order to gain political power and also to dominate the skilled blue-collar occupations, often at the expense of the Chinese and blacks.[15]

Fleeing pogroms and religious persecution in Russia, the Jews were driven from what John Cuddihy described as the "Middle Ages into the Anglo-American world of the *goyim* 'beyond the pale.'" To them, America represented the Promised Land. This vision led Jews to struggle not only for themselves but also for other oppressed groups, especially blacks. After the 1917 East St. Louis race riot, the Yiddish *Forward* of New York compared this anti-black violence to a 1903 pogrom in Russia: "Kishinev and St. Louis—the same soil, the same people." Jews cheered when Jackie Robinson broke into Brooklyn Dodgers in 1947. "He was adopted as the surrogate hero by many of us growing up at the time," recalled Jack Greenberg of the NAACP Legal Defense Fund. "He was the way we saw ourselves triumphing against the forces of bigotry and ignorance." Jews stood shoulder to shoulder with blacks in the Civil Rights Movement: two-thirds of the white volunteers who went south during the 1964 Freedom Summer were Jewish. Today, Jews are considered a highly successful "ethnic" group. How did they make such great socioeconomic strides? This question is often reframed by neoconservative intellectuals like Irving Kristol and Nathan Glazer to read: if Jewish immigrants were able to lift themselves from poverty into the mainstream through self-help and education without welfare and affirmative action, why couldn't blacks? But what this thinking overlooks is the unique history of Jewish immi-

grants, especially the initial advantages of many of them as literate and skilled. Moreover, it minimizes the virulence of racial prejudice rooted in American slavery.[16]

Indians represent a critical contrast, for theirs was not an immigrant experience. The Wampanoags were on the shore as the first English strangers arrived in what would be called "New England." The encounters between Indians and whites not only shaped the course of race relations, but also influenced the very culture and identity of the general society. The architect of Indian removal, President Andrew Jackson, told Congress: "Our conduct toward these people is deeply interesting to the national character." Frederick Jackson Turner understood the meaning of this observation when he identified the frontier as our transforming crucible. At first, the European newcomers had to wear Indian moccasins and shout the war cry. "Little by little," as they subdued the wilderness, the pioneers became "a new product" that was "American." But Indians have had a different view of this entire process. "The white man," Luther Standing Bear of the Sioux explained, "does not understand the Indian for the reason that he does not understand America." Continuing to be "troubled with primitive fears," he has "in his consciousness the perils of this frontier continent. . . . The man from Europe is still a foreigner and an alien. And he still hates the man who questioned his path across the continent." Indians questioned what Jackson and Turner

trumpeted as "progress." For them, the frontier had a different "significance": their history was how the West was lost. But their story has also been one of resistance. As Vine Deloria Jr. declared, "Custer died for your sins."[17]

By looking at these groups from a multicultural perspective, we can comparatively analyze their experiences in order to develop an understanding of their differences and similarities. Race has been a social construction that has historically set apart racial minorities from European immigrant groups. Contrary to the notions of scholars like Nathan Glazer and Thomas Sowell, race in America has not been the same as ethnicity. A broad comparative focus also allows us to see how the varied experiences of different racial and ethnic groups occurred within shared contexts.

During the nineteenth century, for example, the Market Revolution employed Irish immigrant laborers in New England factories as it expanded cotton fields worked by enslaved blacks across Indian lands toward Mexico. Like blacks, the Irish newcomers were stereotyped as "savages," ruled by passions rather than "civilized" virtues such as self-control and hard work. The Irish saw themselves as the "slaves" of British oppressors, and during a visit to Ireland in the 1840s, Frederick Douglass found that the "wailing notes" of the Irish ballads he heard reminded him of the "wild notes" of slave songs. The United States annexation of California, while incorporating Mexicans, led to trade with Asia and the migration of

"strangers" from Pacific shores. In 1870, Chinese immigrant laborers were transported to Massachusetts as scabs to break an Irish immigrant strike; in response, the Irish recognized the need for interethnic working-class solidarity and tried to organize a Chinese lodge of the Knights of St. Crispin. After the Civil War, Mississippi planters recruited Chinese immigrants to discipline the newly-freed blacks. During the debate over an immigration exclusion bill in 1882, a senator asked: If Indians could be located on reservations, why not the Chinese?[18]

Other instances of our connectedness abound. In 1903, Mexican and Japanese farm laborers went on strike together in California: their union officers had names like Yamaguchi and Lizarras, and strike meetings were conducted in Japanese and Spanish. The Mexican strikers declared that they were standing in solidarity with their "Japanese brothers" because the two groups had toiled together in the fields and were now fighting together for a fair wage. Speaking in impassioned Yiddish during the 1909 "uprising of twenty thousand" strikers in New York, the charismatic Clara Lemlich compared the abuse of Jewish female garment workers to the experience of blacks: "[The bosses] yell at the girls and 'call them down' even worse than I imagine the Negro slaves were in the South." During the 1920s, elite universities like Harvard worried about the increasing numbers of Jewish students, and new admissions criteria were institut-

ed to curb their enrollment. Jewish students were scorned for their studiousness and criticized for their "clannishness." Recently, Asian American students have been the targets of similar complaints: they have been called "nerds" and told there are "too many" of them on campus.[19]

Indians were already here while blacks were forcibly transported to America, and Mexicans were initially enclosed by America's expanding border. The other groups came here as immigrants: for them, America represented liminality—a new world where they could pursue extravagant urges and do things they had thought beyond their capabilities. Like the land itself, they found themselves "betwixt and between all fixed points of classification." No longer fastened as fiercely to their old countries, they felt a stirring to become new people in a society still being defined and formed.[20]

These immigrants made bold and dangerous crossings, pushed by political events and economic hardships in their homelands and pulled by America's demand for labor, as well as by their own dreams for a better life. "By all means let me go to America," a young man in Japan begged his parents. He had calculated that in one year as a laborer here he could save almost a thousand yen—an amount equal to the income of a governor in Japan. "My dear Father," wrote an immigrant Irish girl living in New York, "Any man or woman without a family are fools that would not venture

and come to this plentyful Country where no man or woman ever hungered." In the shtetls of Russia, the cry "To America!" roared like "wildfire." "America was in everybody's mouth," a Jewish immigrant recalled. "Businessmen talked [about] it over their accounts; the market women made up quarrels that they might discuss it from stall to stall; people who had relatives in the famous land went around reading their letters." Similarly, for Mexican immigrants crossing the border in the early twentieth century, El Norte became the stuff of overblown hopes. "If only you could see how nice the United States is," they said, "that is why the Mexicans are crazy about it."[21]

The signs of America's ethnic diversity can be discerned across the continent—Ellis Island, Angel Island, Chinatown, Harlem, South Boston, the Lower East Side, places with Spanish names like Los Angeles and San Antonio or Indian names like Massachusetts and Iowa. Much of what is familiar in America's cultural landscape actually has ethnic origins. The Bing cherry was developed by an early Chinese immigrant named Ah Bing. American Indians were cultivating corn, tomatoes, and tobacco long before the arrival of Columbus. The term *okay* was derived from the Choctaw word *oke*, meaning "it is so." There is evidence indicating that the name *Yankee* came from the Indian terms for the English—from *eankke* in Cherokee and *Yankwis* in Delaware. Jazz and blues, as well as rock and roll, have African American origins. The "Forty-Niners" of the Gold Rush learned mining techniques from the Mexicans; American cowboys acquired herding skills from Mexican *vaqueros* and adopted their range terms—such as *lariat* from *la reata*, *lasso* from *lazo*, and *stampede* from *estampida*. Songs like "God Bless America," "Easter Parade," and "White Christmas" were written by a Russian-Jewish immigrant named Israel Baline, more popularly known as Irving Berlin.[22]

Furthermore, many diverse ethnic groups have contributed to the building of the American economy, forming what Walt Whitman saluted

> MANY DIVERSE ETHNIC GROUPS HAVE CONTRIBUTED TO THE BUILDING OF THE AMERICAN ECONOMY, FORMING WHAT WALT WHITMAN SALUTED AS "A VAST, SURGING, HOPEFUL ARMY OF WORKERS."

as "a vast, surging, hopeful army of workers." They worked in the South's cotton fields, New England's textile mills, Hawaii's canefields, New York's garment factories, California's orchards, Washington's salmon canneries, and Arizona's copper mines. They built the railroad, the great symbol of America's industrial triumph. Laying railroad ties, black laborers sang:

Down the railroad, um-huh
Well, raise the iron, um-huh
Raise the iron, um-huh.

Irish railroad workers shouted as they stretched an iron ribbon across the continent:

Then drill, my Paddies, drill—
Drill, my heroes, drill,
Drill all day; no sugar in your tay
Workin' on the U.P. railway.

Japanese laborers in the Northwest chorused as their bodies fought the fickle weather:

A railroad worker—
That's me!
I am great.
Yes, I am a railroad worker.
Complaining:
"It is too hot!"
"It is too cold!"
"It rains too often!"
"It snows too much!"
They all ran off.
I alone remained.
I am a railroad worker!

Chicano workers in the Southwest joined in as they swore at the punishing work:

Some unloaded rails
Others unloaded ties,
And others of my companions
Threw out thousands of curses.[23]

Moreover, our diversity was tied to America's most serious crisis: the Civil War was fought over a racial issue—slavery. In his "First Inaugural Address," presented on March 4, 1861, President Abraham Lincoln declared: "One section of our country believes slavery is *right* and ought to be extended, while the other believes it is *wrong* and ought not to be extended." Southern secession, he argued, would be anarchy. Lincoln sternly warned the South that he had a solemn oath to defend and preserve the Union. Americans were one people, he explained, bound together by "the mystic chords of memory, stretching from every battlefield and patriot grave to every living heart and hearthstone all over this broad land." The struggle and sacrifices of the War for Independence had enabled Americans to create a new nation out of thirteen separate colonies. But Lincoln's appeal for unity fell on deaf ears in the South. And the war came. Two-and-a-half years later, at Gettysburg, President Lincoln declared that "brave men" had fought and "consecrated" the ground of this battlefield in order to preserve the Union. Among the brave were black men. Shortly after this bloody battle, Lincoln acknowledged the military contributions of blacks. "There will be some black men," he wrote in a letter to an old friend, James C. Conkling, "who can remember that with silent tongue, and clenched teeth, and steady eye, and well-poised bayonet, they have helped mankind on to this great consummation. . . ." Indeed, 186,000 blacks served in the Union Army, and one-third of them were listed as missing or dead. Black men in blue, Frederick Douglass pointed out, were "on the battlefield mingling their blood with that of white men in one common effort to save the country." Now the mystic chords of memory stretched across the new battlefields of the Civil War, and black soldiers were buried in "patriot graves."

They, too, had given their lives to ensure that the "government of the people, by the people, for the people, shall not perish from the earth."[24]

These black soldiers, like all the people discussed here, have been actors in history, not merely victims of discrimination and exploitation. They are entitled to be viewed as subjects—as men and women with minds, wills, and voices.

In the telling and retelling
of their stories,
They create communities
of memory.

They also re-vision history. "It is very natural that the history written by the victim," said a Mexican in 1874, "does not altogether chime with the story of the victor." Sometimes they are hesitant to speak, thinking they are only "little people." "I don't know why anybody wants to hear my history," an Irish maid said apologetically in 1900. "Nothing ever happened to me worth the tellin'."[25]

But their stories are worthy. Through their stories, the people who have lived America's history can help all of us—including my taxi driver—understand that Americans originated from many shores, and that all of us are entitled to dignity. "I hope this survey do a lot of good for Chinese people," an immigrant told an interviewer from Stanford University in the 1920s. "Make American people realize that Chinese people are humans. I think very few American people really know anything about Chinese." But the remembering is

also for the sake of the children. "This story is dedicated to the descendants of Lazar and Goldie Glauberman," Jewish immigrant Minnie Miller wrote in her autobiography. "My history is bound up in their history and the generations that follow should know where they came from to know better who they are." Similarly, Tomo Shoji, an elderly Nisei woman, urged Asian Americans to learn more about their roots: "We got such good, fantastic stories to tell. All our stories are different." Seeking to know how they fit into America, many young people have become listeners; they are eager to learn about the hardships and humiliations experienced by their parents and grandparents. They want to hear their stories, unwilling to remain ignorant or ashamed of their identity and past.[26]

The telling of stories liberates. By writing about the people on Mango Street, Sandra Cisneros explained, "the ghost does not ache so much." The place no longer holds her with "both arms. She sets me free." Indeed, stories may not be as innocent or simple as they seem to be. Native-American novelist Leslie Marmon Silko cautioned:

I will tell you something about stories. . .
They aren't just entertainment.
Don't be fooled.

Indeed, stories vibrantly re-create moments, and capture the complexities of human emotions and thoughts. They also provide the authenticity of experience. After she escaped from slavery, Harriet Jacobs wrote in her autobiography: "[My purpose] is not to tell you what I have heard but what I have seen—and what I have suffered." In the sharing of memory, such stories offer us an opportunity to see ourselves reflected in a mirror called history.[27]

In his recent study of Spain and the New World, *The Buried Mirror*, Carlos Fuentes points out that mirrors have been found in the tombs of ancient Mexico, placed there to guide the dead through the underworld. He also tells us about the leg-

SEEKING TO KNOW HOW THEY FIT INTO AMERICA, MANY YOUNG PEOPLE HAVE BECOME LISTENERS; THEY ARE EAGER TO LEARN ABOUT THE HARDSHIPS AND HUMILIATIONS EXPERIENCED BY THEIR PARENTS AND GRANDPARENTS.

end of Quetzalcoatl, the Plumed Serpent: when this god was given a mirror by the Toltec deity Tezcatlipoca, he saw a man's face in the mirror and realized his own humanity. For us, the "mirror" of history can guide the living and also help us recognize who we have been and hence are. In *A Distant Mirror*, Barbara W. Tuchman finds "phenomenal parallels" between the "calamitous fourteenth century" of European society and our own era. We can, she observes, have "greater fellow-feeling for a distraught age" as we painfully recognize the "similar disarray," "collapsing assumptions," and "unusual discomfort."[28]

But what is needed in our own perplexing times is not much a "distant" mirror, as one that is "different." While the study of the past can provide collective self-knowledge,

it often reflects the scholar's particular perspective or view of the world. What happens when historians leave out many of America's peoples? What happens, to borrow the words of Adrienne Rich, "when someone with the authority of a teacher" describes our society, and "you are not in it"? Such an experience can be disorienting—"a moment of psychic disequilibrium, as if you looked into a mirror and saw nothing."[29]

Through their narratives about their lives and circumstances, the people of America's diverse groups are able to see themselves and each other in our common past. They celebrate what Ishmael Reed has described as a society "unique" in the world because "the world is here"—a place "where the cultures of the world crisscross." Much of America's past, they point out, has been riddled with racism. At the same time these people offer hope, affirming the struggle for equality as a central theme in our country's history. At its conception, our nation was dedicated to the proposition of equality. What has given concreteness to this powerful national principle has been our coming together in the creation of a new society. "Stuck here" together, workers of different backgrounds have attempted to get along with each other.

People harvesting
Work together unaware
Of racial problems,

wrote a Japanese immigrant describing a lesson learned by Mexican and Asian farm laborers in California.[30]

Finally, how do we see our prospects for "working out" America's racial crisis? Do we see it as through a glass darkly? Do the televised images of racial hatred and violence that riveted us in 1992 during the days of rage in Los Angeles frame a future of divisive race relations—what Arthur Schlesinger, Jr., has fearfully denounced as the "disuniting of America"? Or will Americans of diverse races and ethnicities be able to connect themselves to a larger narrative? Whatever happens, we can be certain that much of our society's future will be influenced by the "mirror" in which we choose to see ourselves. America does not belong to one race or one group, and Americans have been constantly redefining their national identity from the moment of first contact on the Virginia shore. By sharing their stories, they invite us to see ourselves in a different mirror.[31] ◀

From *A Different Mirror* by Ronald Takaki. Copyright ©1993 by Ronald Takaki. By permission of Little, Brown and Company.

1. Toni Morrison, *Playing in the Dark: Whiteness in the Literary Imagination* (Cambridge, Mass., 1992), p. 47.
2. William A. Henry III, "Beyond the Melting Pot," in "America's Changing Colors," *Time*, vol. 135, no. 15 (April 9, 1990), pp. 28–31.
3. Allan Bloom, *The Closing of the American Mind: How Higher Education Has Failed Democracy and Impoverished the Souls of Today's Students* (New York, 1987), pp. 19, 91–93, 340–341, 344.
4. E.D. Hirsch, Jr., *Cultural Literacy: What Every American Needs to Know* (Boston, 1987), pp. xiii, xvii, 2, 18, 96. See also "The List," pp. 152–215.
5. Edward Fiske, "Lessons," *New York Times*, February 7, 1990; "University of Wisconsin-Madison: The Madison Plan," February 9, 1988; interview with Dean Fred Lukermann, University of Minnesota, 1987.
6. A Conflict of the Have-Nots," *Newsweek*, December 12, 1988, pp. 28–29.
7. Rodney King's statement to the press, *New York Times*, May 2, 1992, p. 6.
8. Time Rutten, "A New Kind of Riot," *New York Review of Books*, June 11, 1992, pp. 52-53; Maria Newman, "Riots Bring Attention to Growing Hispanic Presence in South-Central Area," *New York Times*, May 11, 1992, p. A10; Mike Davis, "In L.A. Burning All Illusions," *The Nation*, June 1, 1992, pp. 744–45; Jack Viets and Peter Fimrite, "S.F. Mayor Visits Riot-Torn Area to Buoy Businesses," *San Francisco Chronicle*, May 6, 1992, p. A6.
9. Rick DelVecchio, Suzanne Espinosa, and Carl Nolte, "Bradley Ready to Lift Curfew," *San Francisco Chronicle*, May 4, 1992, p. A1.
10. Oscar Handlin, *The Uprooted: The Epic Story of the Great Migrations That Made the American People* (New York, 1951); Arthur M. Schlesinger, Jr., *The Age of Jackson* (Boston, 1945).
11. Handlin, *The Uprooted*, p. 3; Irving Howe, *World of Our Fathers: The Journey of the East European Jews to America and the Life They Found and Made* (New York, 1983); Dee Brown, *Bury My Heart at Wounded Knee: An Indian History of the American West* (New York, 1970); Albert Camarillo, *Chicanos in a Changing Society: From Mexican Pueblos to American Barrios in Santa Barbara and Southern California, 1848-1930* (Cambridge, Mass., 1979); Lawrence W. Levine, *Black Culture and Black Consciousness: Afro-American Folk Thought from Slavery to Freedom* (New York, 1977); Yuji Ichioka, *The Issei: The World of the First Generation Japanese Immigrants* (New York, 1988); Kerby A. Miller, *Emigrants and Exiles: Ireland and the Irish Exodus to North America* (New York, 1985).
12. Abraham Lincoln, "The Gettysburg Address," in *The Annals of America*, vol. 9,

1863–1865: The Crisis of the Union (Chicago, 1968), pp. 462–463: Martin Luther King, *Why We Can't Wait* (New York, 1964), pp. 92–93.

13. Interview with old laundryman, in "Interviews with Two Chinese," circa 1924, Box 326, folder 325, Survey of Race Relations, Stanford University, Hoover Institution Archives; Congressman Robert Matsui, speech in the House of Representatives on the 442 bill for redress and reparations, September 17, 1987, *Congressional Record* (Washington, D.C., 1987), p. 7,584.

14. Camarillo, *Chicanos in a Changing Society*, p. 2; Juan Nepomuceno Siguin, in David J. Weber (ed.), *Foreigners in Their Native Land: Historical Roots of the Mexican Americans* (Albuquerque, N. Mex., 1973), p. vi; Jesus Garza, in Manuel Gamio, *The Mexican Immigrant: His Life Story* (Chicago, 1931), p. 15; Ernesto Galarza, *Barrio Boy: The Story of a Boy's Acculturation* (Notre Dame, Ind., 1986), p. 200.

15. Lawrence J. McCaffrey, *The Irish Diaspora in America* (Washington, D.C., 1984), pp. 6, 62.

16. John Murray Cuddihy, *The Ordeal of Civility: Freud, Marx, Levi Strauss, and the Jewish Struggle with Modernity* (Boston, 1987), p. 165; Jonathan Kaufman, *Broken Alliance: The Turbulent Times between Blacks and Jews in America* (New York, 1989), pp. 28, 82, 83–84, 91, 93, 106.

17. Andrew Jackson, First Annual Message to Congress, December 8, 1829, in James D. Richardson (ed.), *A Compilation of the Messages and Papers of the Presidents, 1789–1897* (Washington, D.C., 1897), vol. 2, p. 457; Frederick Jackson Turner, "The Significance of the Frontier in American History," in *The Early Writings of Frederick Jackson Turner* (Madison, Wis., 1938), pp. 185ff.; Luther Standing Bear, "What the Indian Means to America," in Wayne Moquin (ed.), *Great Documents in American Indian History* (New York, 1973), p. 307; Vine Deloria, Jr., *Custer Died for Your Sins: An Indian Manifesto* (New York, 1969).

18. Nathan Glazer, *Affirmative Discrimination: Ethnic Inequality and Public Policy* (New York 1978); Thomas Sowell, *Ethnic America:*

A History (New York, 1981); David R. Roediger, *The Wages of Whiteness: Race and the Making of the American Working Class* (London, 1991), pp. 134–136; Dan Caldwell, "The Negroization of the Chinese Stereotype in California," *Southern California Quarterly*, vol. 33 (June 1971), pp. 123-131.

19. Tomas Almaguer, "Racial Domination and Class Conflict in Capitalist Agriculture: The Oxnard Sugar Beet Workers' Strike of 1903," *Labor History*, vol. 25, no. 3 (summer 1984), p. 347; Howard M. Sachar, *A History of the Jews in America* (New York, 1992), p. 183.

20. For the concept of liminality, see Victor Turner, *Dramas, Fields, and Metaphors: Symbolic Action in Human Society* (Ithaca, N.Y., 1974), pp. 232, 237; and Arnold Van Gennep, *The Rites of Passage* (Chicago, 1960). What I try to do is to apply liminality to the land called America.

21. Kazuo Ito, *Issei: A History of Japanese Immigrants in North America* (Seattle, 1973), p. 33; Arnold Schrier, *Ireland and the American Emigration, 1850–1900* (New York, 1970), p. 24; Abraham Cahan, *The Rise of David Levinsky* (New York, 1960; originally published in 1917), pp. 59–61; Mary Antin, quoted in Howe, *World of Our Fathers*, p. 27; Lawrence A. Cardoso, *Mexican Emigration to the United States, 1897–1931* (Tucson, Ariz., 1981), p. 80.

22. Ronald Takaki, *Stangers from a Different Shore: A History of Asian Americans* (Boston, 1989), pp. 88-89; Jack Weatherford, *Native Roots: How the Indians Enriched America* (New York, 1991), pp. 210, 212; Carey McWilliams, *North from Mexico: The Spanish-Speaking People of the United States* (New York, 1968), p. 154; Stephan Thernstrom (ed.), *Harvard Encyclopedia of American Ethnic Groups* (Cambridge, Mass., 1980), p. 22; Sachar, *A History of the Jews in America*, p. 367.

23. Walt Whitman, *Leaves of Grass* (New York, 1958), p. 284; Mathilde Bunton, "Negro Work Songs" (1940), 1 typescript in Box 91 ("Music"), Illinois Writers Project, U.S.W.P.A., in James R. Grossman, *Land of Hope: Chicago, Black Southerners, and the Great Migration* (Chicago, 1989), p. 192; Carl Wittke, *The Irish in America* (Baton Rouge, La.,

1956), p. 39; Ito, *Issei*, p. 343; Manuel Gamio, *Mexican Immigration to the United States* (Chicago, 1930), pp. 84–85.

24. Abraham Lincoln, "First Inaugural Address," in *The Annals of America*, vol. 9, *1863–1865: The Crisis of the Union* (Chicago, 1968), p. 255; Lincoln, "The Gettysburg Address," pp. 462–463; Abraham Lincoln, letter to James C. Conkling, August 26, 1863, in *Annals of America*, p. 439; Frederick Douglass, in Herbert Aptheker (ed.), *A Documentary History of the Negro People in the United States* (New York, 1951), vol. 1, p. 496.

25. Weber (ed.), *Foreigners in Their Native Land*, p. vi; Hamilton Holt (ed.), *The Life Stories of Undistinguished Americans as Told by Themselves* (New York, 1906), p. 143.

26. "Social Document of Pany Lowe, interviewed by C. H. Burnett, Seattle, July 5, 1924," p. 6, Survey of Race Relations, Stanford University, Hoover Institution Archives; Minnie Miller, "Autobiography," private manuscript, copy from Richard Balkin; Tomo Shoji, presentation, Ohana Cultural Center, Oakland, California, March 4, 1988.

27. Sandra Cisneros, *The House on Mango Street* (New York, 1991), pp. 109–110; Leslie Marmon Silko, *Ceremony* (New York, 1978), p. 2; Harriet A. Jacobs, *Incidents in the Life of a Slave Girl, written by herself* (Cambridge, Mass., 1987; originally published in 1857), p. xiii.

28. Carlos Fuentes, *The Buried Mirror: Reflections on Spain and the New World* (Boston, 1992), pp. 10, 11, 109; Barbara W. Tuchman, *A Distant Mirror: The Calamitous 14th Century* (New York, 1978), pp. xiii, xiv.

29. Adrienne Rich, *Blood, Bread, and Poetry: Selected Prose, 1979-1985* (New York, 1986), pp. 199.

30. Ishmael Reed, "America: The Multinational Society," in Rick Simonson and Scott Walker (eds.), *Multi-cultural Literacy* (St. Paul, 1988), p. 160; Ito, *Issei*, p. 497.

31. Arthur M. Schlesinger, Jr., *The Disuniting of America: Reflections on a Multicultural Society* (Knoxville, Tenn., 1991); Carlos Bulosan, *America Is in the Heart: A Personal History* (Seattle, 1981), pp. 188–189.

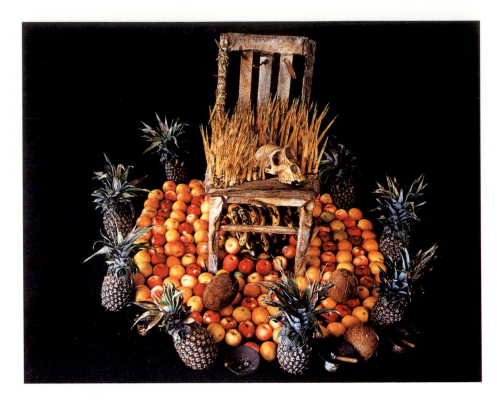

ALBERT CHONG

THE RECENT DEATH OF MY FATHER crystallized for me the tenuous link I have with the past. With his passing, I have lost the most important link I had with my past, a history about myself and my family. I have come to realize that I am a walking repository of cultural, familial, and genetic information. In addition, I now realize that I shared with my father a closer history than my children will share with me. Their upbringing in America creates a cultural identity that, with each generation, will grow more distant from mine and that of my father. Like others who trace their ancestry to foreign shores, I am duty-bound to my descendants to pass on my personal and familial stories, and ultimately the stories of culture and race.

My ancestral dialogues are a constant discourse with the spirits of the past. This work is an attempt to fuse the practices inherent in the cosmological system of my life with the art-making process. In these images, I strive to eliminate the distinctions between art and life, ritual, magic, and my personal brand of mysticism. I seek to bring home the ancestral spirits and seat them on the thrones that have been created for them, upon and about which offerings are made. —Albert Chong

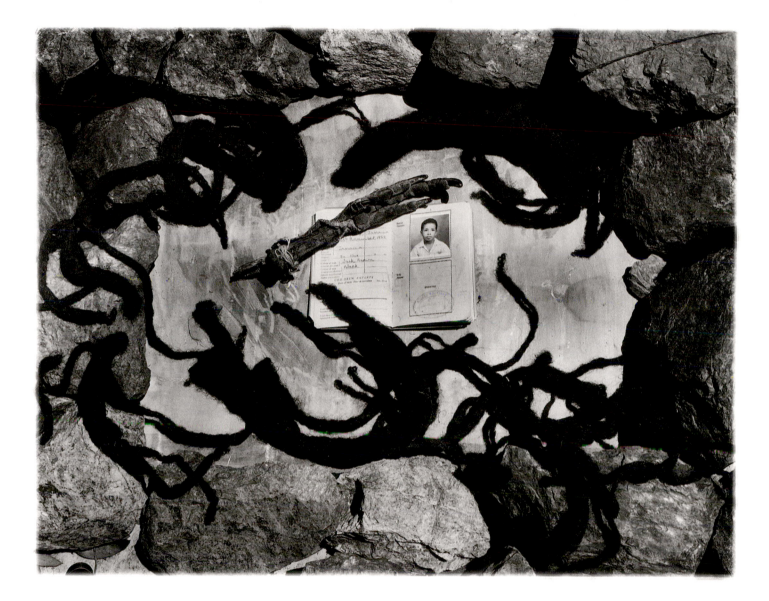

Passages and Totems, 1990. Gelatin silver print. 16 by 20 in. Courtesy of the artist

Facing page: *Throne for the Gorilla Spirits*, 1993. Chromogenic dye bleach print, 30 by 40 in. Courtesy of the artist

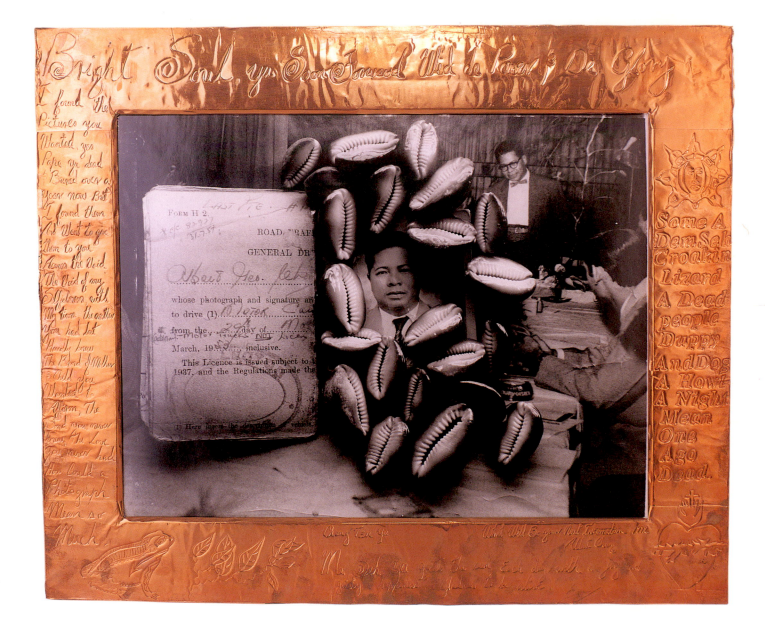

What Will be Your Next Incarnation?, from the series *The Justice*, 1990–1994. Gelatin silver print, inscribed copper mat, 20 by 24 in. Courtesy of the artist

Facing Page: *Jesus, Mary and the Perfect White Man*, 1988–1995. Gelatin silver print, inscribed copper mat, 48 by 40 in. Courtesy of the artist

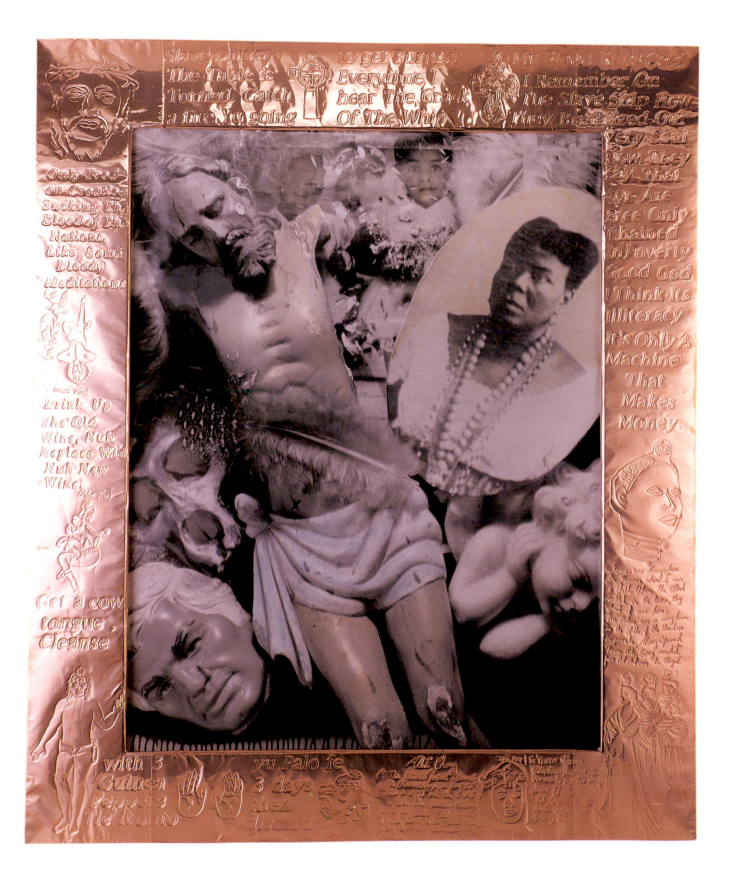

Winnifred Lynn was 80 years old on Oct 30th 1994. Aunt Maudie told her that she was born in 1914 in Vere Clarendon She was born first then her twin brother was born & died soon after. "your mother began throwing herself from side to side on the bed & died

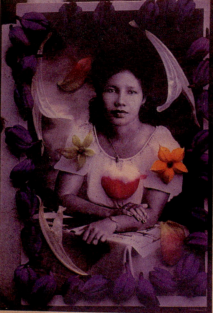

Her father, a full Chinese man named Thomas Lyn she called "Papa Tom" (Our grandfather was a musican who played a flute He was living with Louise Hinds our grandmother she went to live with her her father and Aunt Lou who did not like her and treated her like Cinderella.

Papa Tom took care of everyone As most Chinese men always take care of their family and easy with money Her father was kind quiet man who suffered ridicule because he had to raise a "black baby" who obviously was not his because she was having an affair with Douce Beryl's father, who it seems was the person Aunt Lou really loved

One morning Winnie went to Aunt Lou told her "Papa Tom look sick and not moving Aunt Lou said "nothing wrong with him". She saw her father shudder was afraid and called a Chinese lady next door her father was dead she had no one left. She remembers the old people passing her over her Father's body

Aunt Winnie's Story, 1994. Thermal transfer print on canvas, inscribed copper mat, 30 by 20 in. Courtesy of the artist

30

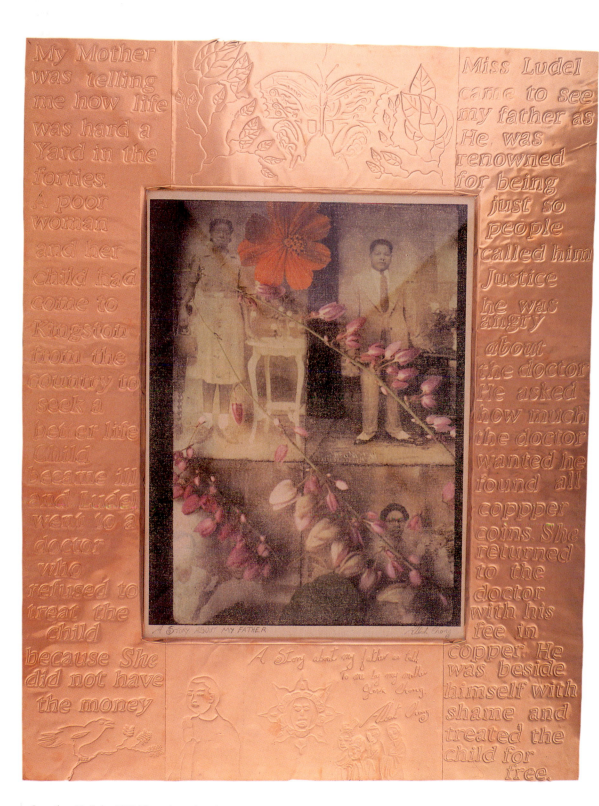

My Mother was telling me how life was hard a Yard in the forties. A poor woman and her child had come to Kingston from the country to seek a better life Child became ill and Ludel went to a doctor who refused to treat the child because She did not have the money

Miss Ludel came to see my father as He was renowned for being just so people called him Justice he was angry about the doctor He asked how much the doctor wanted he found all coppper coins. She returned to the doctor with his fee in copper. He was beside himself with shame and treated the child for free.

A Story about my father as told To me by my mother Gloria Chong.

Albert Chong

Story About My Father, 1994. Thermal transfer print on canvas, inscribed copper mat, 30 by 20 in. Courtesy of the artist

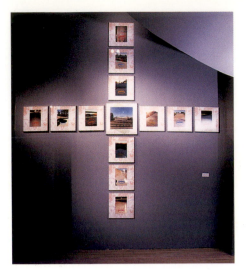

Mt. SLOVER IS A SITE IN COLTON, CALIFORNIA, located approximately fifty miles due east of Los Angeles, just south of Interstate 10. This mountain is an anonymous sculpture on a grand scale, not unlike the pyramids of Egypt. It is a mountain transformed into the shapes of civilization: roads, sidewalks, and buildings. The concept of this vast transformation of material into different forms, spreading over thousands of square miles, is powerful, grandiose, and awe-inspiring.

Before the time of man, this mountain stood nameless, submerged in waters that eventually shrank to become the timid Santa Ana River. Unlike other formations around it, this particular geographical mass was uniquely solid. The Cahuilla Indians called it Tahualtapa or Tacamalcay—"The Hill of the Ravens." The invading Spanish renamed the site Cerrito Solo, or "The Little Mountain that Stands Alone." The first name given by white settlers in the nineteenth century was "Marble Mountain" because of the rich vein of high-grade limestone that ran through the mountain's center. Marble columns and facings from this site can be found in many older buildings in and around Los Angeles. Later, the mountain was named Mt. Slover after the pioneer Isaac Slover, who had lived in its soon-to-disappear shadow.

Until the formation of the California Portland Cement Company, cement was imported to this area from England, Spain, and Germany. Mt. Slover was found to be composed almost entirely of granidiorite, a unique material that was discovered to be useful in binding together brick and stone. This mineral is pulverized, heated, and re-pulverized to make an interlocking compound that, when mixed with water, sand, and stones, makes concrete.

These images represent varying solutions for visual and conceptual analogies of Tahualtapa.—Lewis deSoto

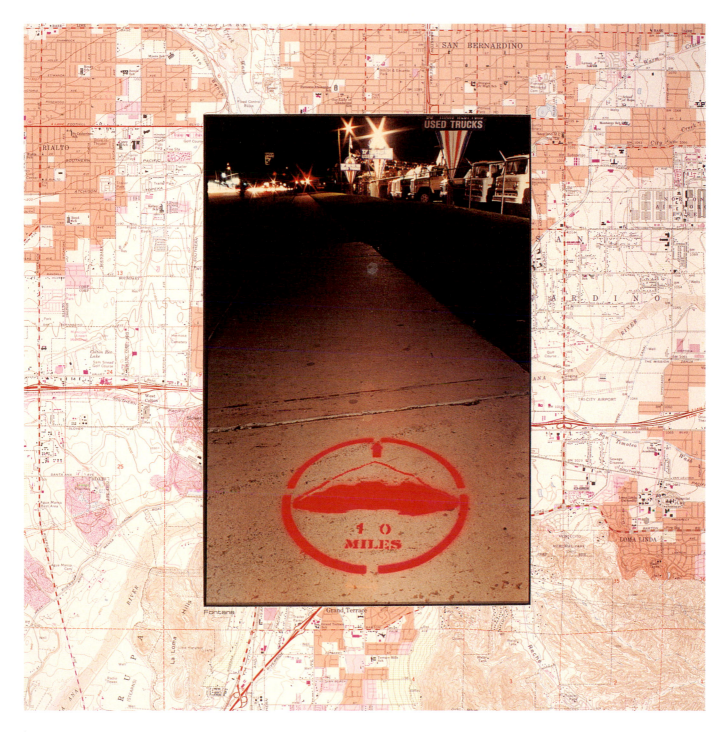

Detail from *Slover Compass*, from the installation
Tahualtapa (Hill of the Ravens), 1987–1988. Collection
of the Seattle Art Museum, gift of the artist

Facing Page: *Slover Compass*, from the installation
Tahualtapa (Hill of the Ravens), 1987–1988. Chromo-
genic prints and maps, 123 by 123 in. overall.
Collection of the Seattle Art Museum, gift of the artist

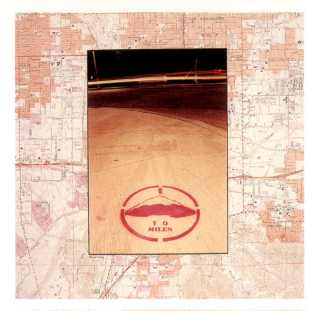

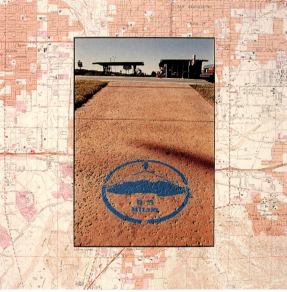

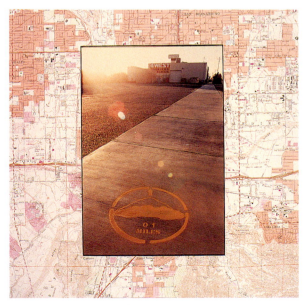

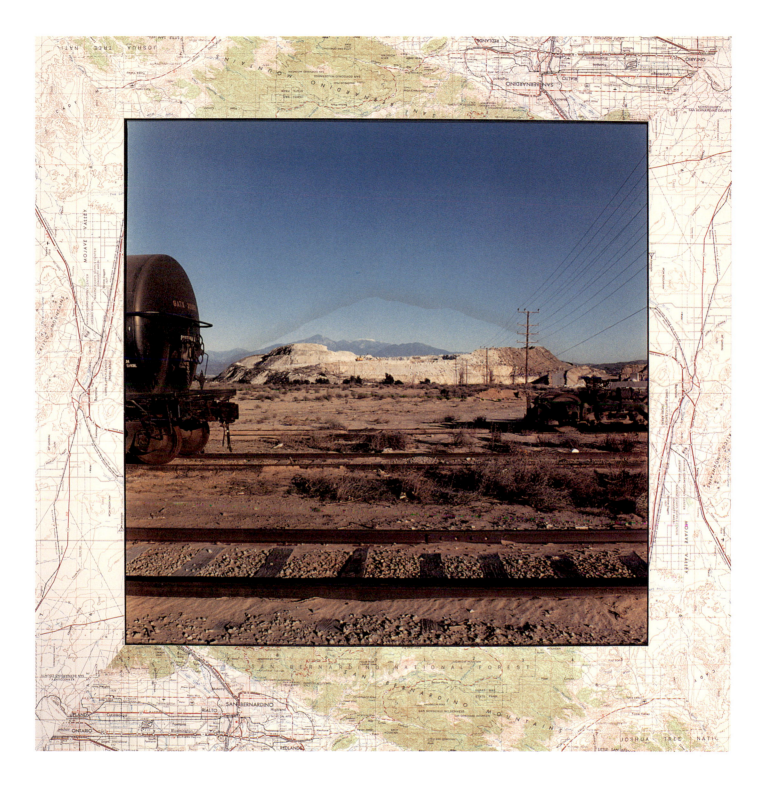

Details from *Slover Compass,* from the installation *Tahual-
tapa (Hill of the Ravens)*, 1987–1988. Collection of the
Seattle Art Museum, gift of the artist

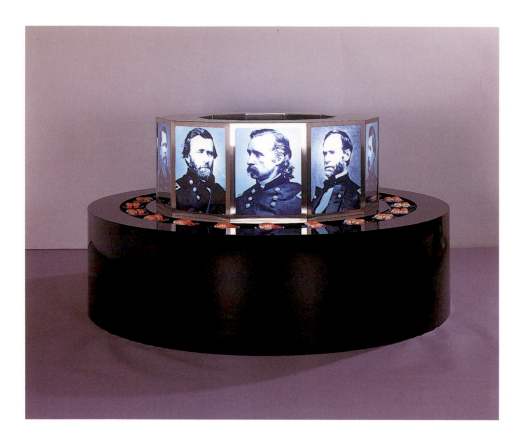

I.T.O.

I HAVE LIVED IN AND OBSERVED TWO DIFFERENT CULTURES, Japanese and American. Being in the United States as a foreigner forced me to evaluate my natural acculturation as a Japanese. My customs, morals, beliefs, and values suddenly were exposed to a different superstructure. My Japanese ways of doing and understanding things were not necessarily appropriate for accurate communication. My attempts continually fell short of my intentions. I had to force myself to adjust certain aspects of my value system in order to function in the United States. This experience compelled me to create art about existing between two cultures, and about how things are seen or understood differently depending on their cultural context. My objective is to create works of art that help viewers cross cultural boundaries and address questions of prejudice, misunderstanding, greediness, and discrimination.

The virtue of capitalism is that it connects countries through free enterprise. Companies have established factories and offices all over the world. Interactions among countries have been enhanced through a growing economy and expanding technology. This phenomenon results in forced fusions of

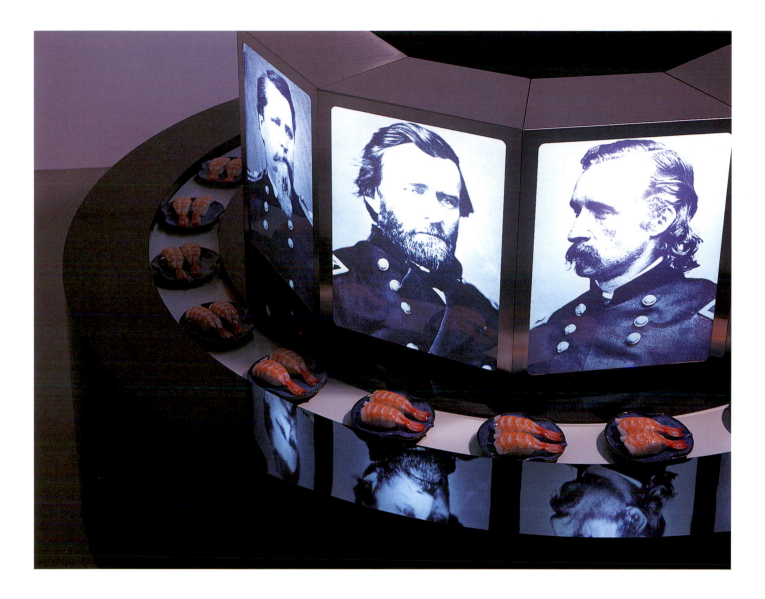

ethnic groups, races, religions, and cultures on a global level. Capitalism, however, does not always respect the values of other cultures. My work questions whether the nature of these fusions is different from the imperialism and colonialism that were prevalent during the early nineteenth century.

My work consists of different symbols from Japanese and American culture. Symbols, such as religious icons, mythological figures, and popular images, have developed historically within different cultural meanings. In my work, I appropriate and compose these elements in order to present new visual interpretations that I hope will decrease antagonistic conflicts between people from different cultural backgrounds, and encourage people to cross cultural boundaries. —I.T.O.

#031 Ethnocentrism II—The Revenge of Sushi, from the series *Interculturism*, 1990–1995. Mixed media installation, 37½ by 72 by 72 in. overall. Courtesy of the artist

#011 Staple, 1990–1995. Mixed media installation, 31½ by 114 by 6 ¾ in. overall. Courtesy of the artist

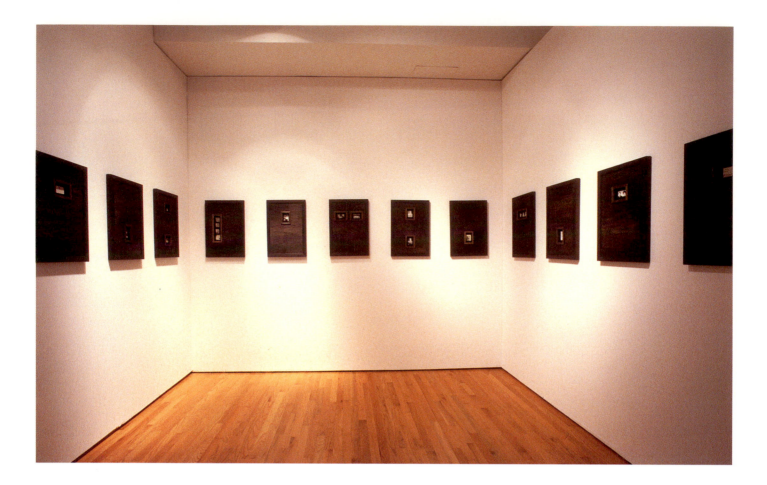

IT IS IRONIC AND HUMOROUS THAT I FEEL SO CLOSE and yet so distant to Korea. With each visit, as I see my parents aging and sense time passing, I'm aware of an increasing distance. We know each other and yet we don't know each other. My work reflects the continuous process of negotiation between two cultures. It is based on my experience of immigration and of locating myself in relation to ever-changing definitions of home in personal, social, and cultural contexts.

Distances is comprised of twelve panels. By combining image and language with sculptural elements, its format somewhat resembles Asian scroll painting. By invoking this genre, I hope to suggest a sense of absence of the past. Photographs from my family photo albums provide visual information. The text on each panel is self-contained so that each piece can stand on its own; viewed as a whole, however, they create a personal narrative. —Young Kim

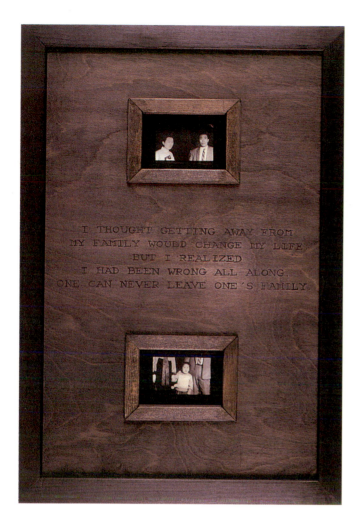

Facing page: *Distances*, 1992. Twelve gelatin silver prints, plywood, ink, acrylic. 22 by 15 in. each; 22 in. by 25 ft. overall. Courtesy of the artist

Above: *Distances #3*, detail from the installation *Distances*, 1992. Gelatin silver prints, plywood, ink, acrylic, 22 by 15 in. Courtesy of the artist

Right: *Distances #7*, detail from the installation *Distances*, 1992. Gelatin silver prints, plywood, ink, acrylic, 22 by 15 in. Courtesy of the artist

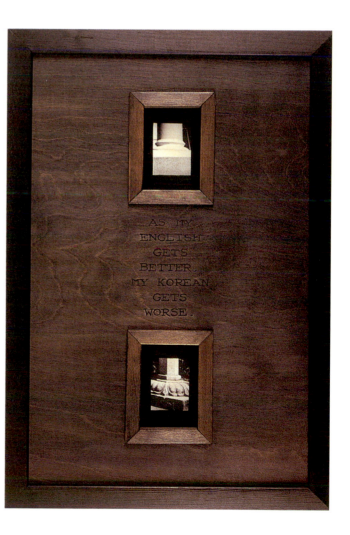

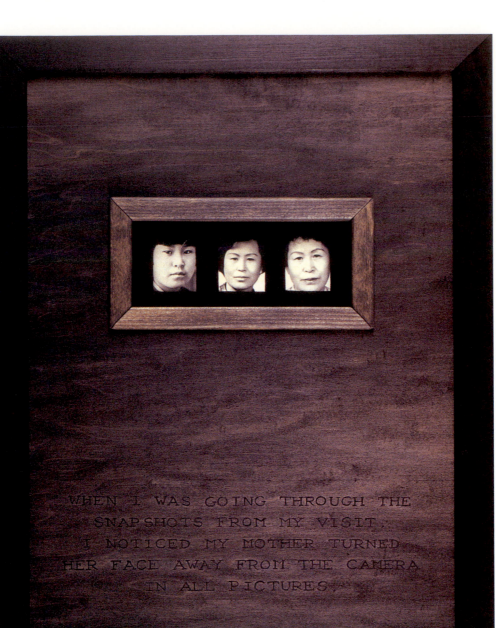

WHEN I WAS GOING THROUGH THE
SNAPSHOTS FROM MY VISIT,
I NOTICED MY MOTHER TURNED
HER FACE AWAY FROM THE CAMERA
IN ALL PICTURES.

Distances #9, detail from the installation *Distances*, 1992.
Gelatin silver prints, plywood, ink, acrylic, 22 by 15 in.
Courtesy of the artist

42

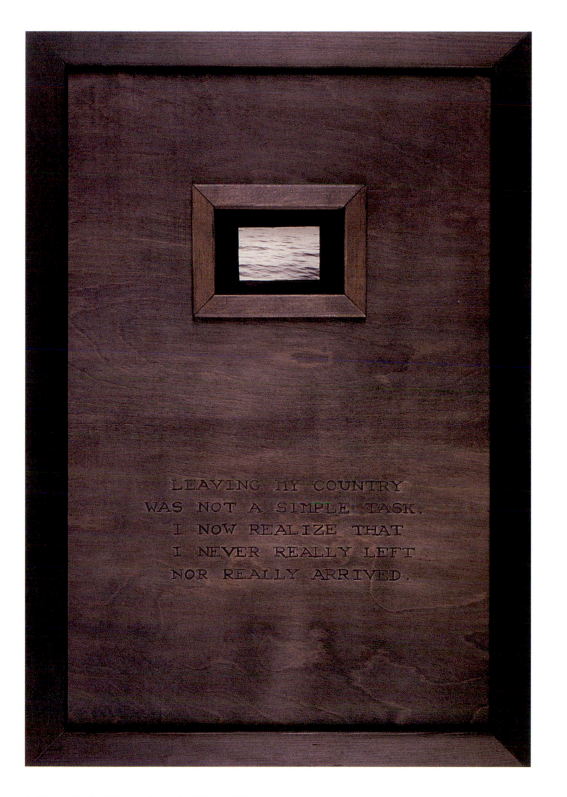

LEAVING MY COUNTRY
WAS NOT A SIMPLE TASK.
I NOW REALIZE THAT
I NEVER REALLY LEFT
NOR REALLY ARRIVED.

Distances #12, detail from the installation *Distances*, 1992.
Gelatin silver prints, plywood, ink, acrylic, 22 by 15 in.
Courtesy of the artist

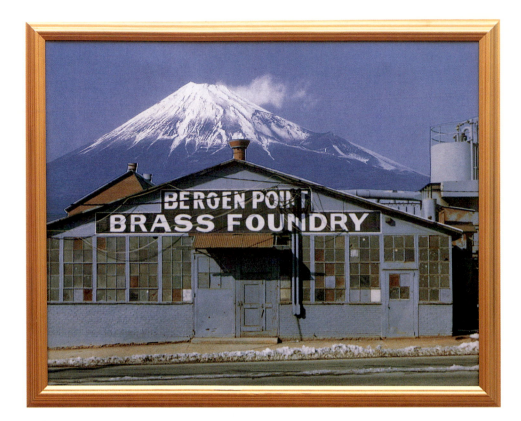

KOMAR & MELAMID

ALMOST IMMEDIATELY AFTER EMIGRATING TO THE UNITED STATES in 1978, we discovered Bayonne, New Jersey, a small, working-class town in Hudson County just ten minutes away from the metropolis of Manhattan. As former Russians, we were impressed by its simplicity and its ethnic diversity. We felt comfortable within its environs, as did its past and present residents from a variety of cultural backgrounds. Our ancestral roots influenced everything we saw and experienced in Bayonne, which we considered an ordinary American town.

One of our early works as new Americans was a painting of the Kremlin as viewed from Manhattan. This series of photographs represents a return to our fascination with and exploration of America and its ability to accommodate varied cultures from around the world. — Komar & Melamid

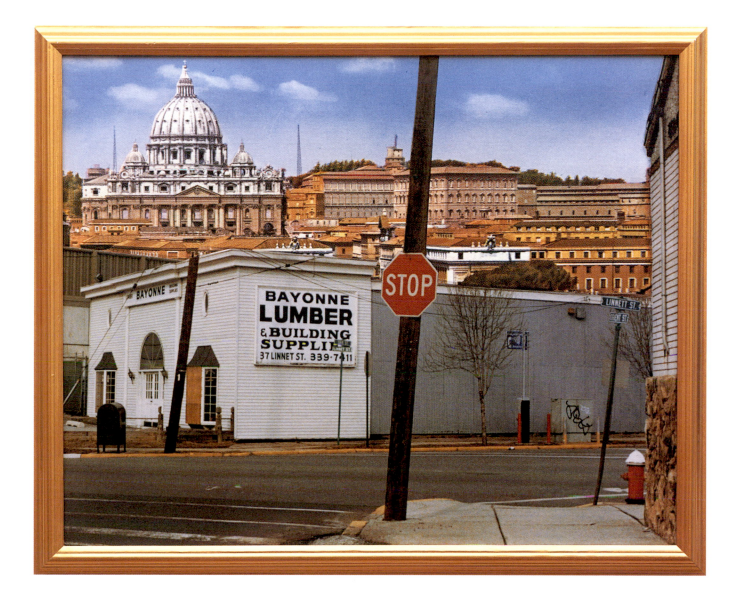

Untitled, from the series *Bayonne*, 1990. Chromogenic prints, collage, 30 by 40 in. Courtesy of the artists

Facing page: Untitled, from the series *Bayonne*, 1990. Chromogenic prints, collage, 30 by 40 in. Courtesy of the artists

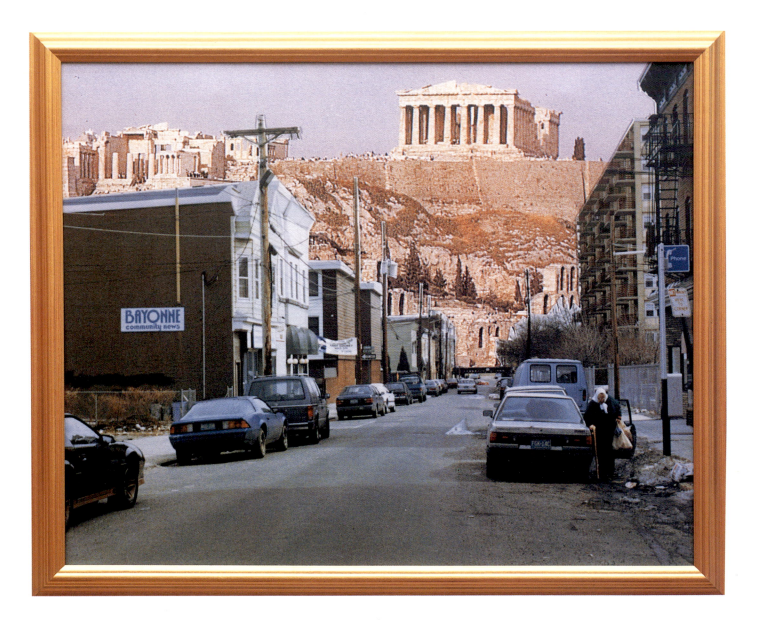

Untitled, from the series *Bayonne*, 1990. Chromogenic prints, collage, 30 by 40 in. Courtesy of the artists

Facing page: Untitled, from the series *Bayonne*, 1990. Chromogenic prints, collage, 40 by 30 in. Courtesy of the artists

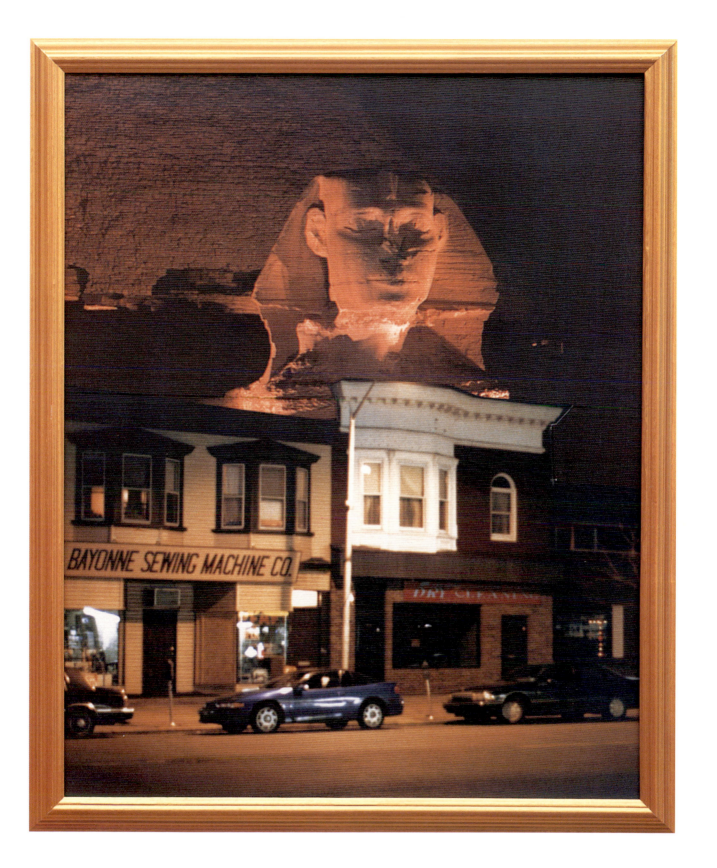

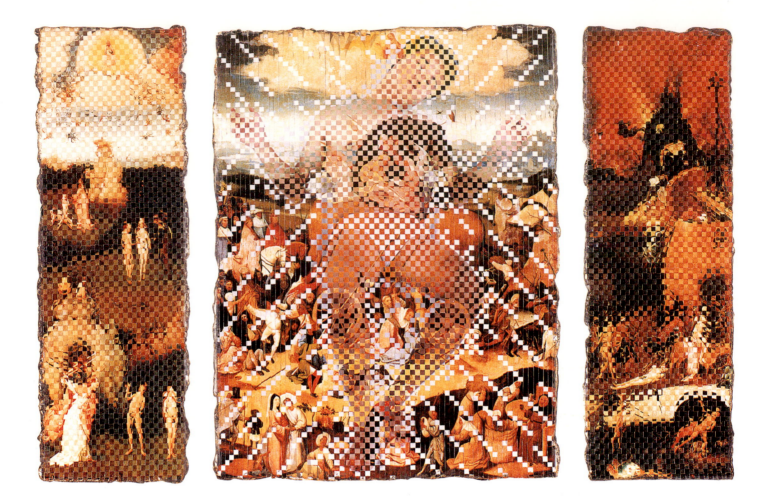

Portraying a White God is about my effort to establish my identity in relationship to the culture I have entered. As a Vietnamese living in Western society, educated in Western institutions, and surrounded by Western experiences, I am a product of both East and West. What does this Western culture mean to me, as someone from the outside coming in and adopting it? By placing myself among other mythologies and cultures within my images, I dissect the meanings of these constructs and create a new mythology that serves my own needs. —Dinh Q. Le

Self Portrait After Bosch, "The Temptation of St. Anthony," 1991. Chromogenic prints and linen tape, 40 by 57 in. overall. Courtesy of the artist

Facing page: *Self Portrait with Angel from the Perússis Alterpiece,* 1990. Chromogenic prints and linen tape, 40 by 30 in. Courtesy of the artist

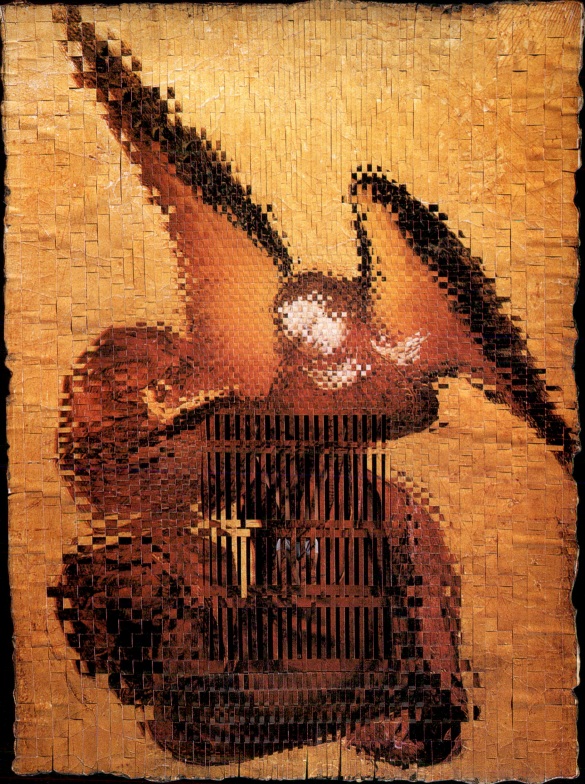

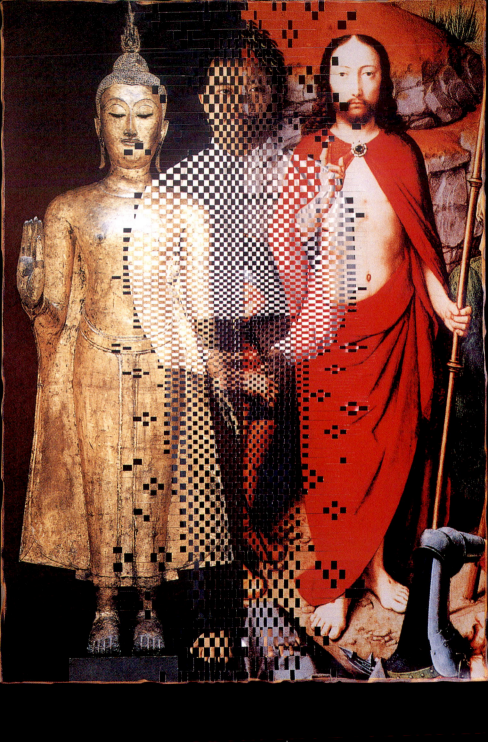

Interconfined, 1994. Chromogenic prints and linen
55 by 39 in. Courtesy of the artist

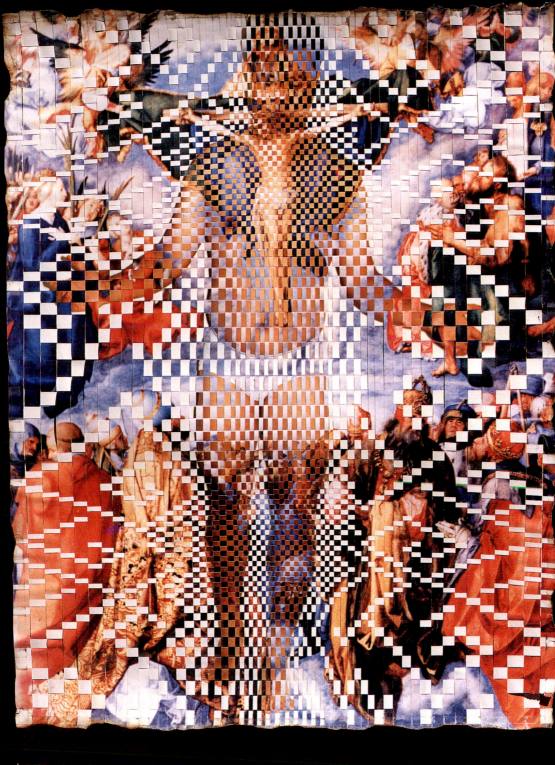

Self Portrait #15, from the series *Portraying a White God*,
1989. Chromogenic prints and linen tape, 40 by 30 in.
Courtesy of the artist

IN THE SPRING OF 1993, I made plans to visit San Francisco and research my great-grandfather's past. A few years earlier, I had been told that my great-grandfather, George Lim Fong, had attempted to assassinate a visiting Chinese government official in 1910. He was caught and sent to San Quentin. This is all that I was told.

A week before my journey to San Francisco, I received a call from my mother, Sandra Lee. "You'll never guess what happened!" she said. She had visited her friend, Richard Hoy, who happened to show her an album of Chinese criminals. "That's my Grandpa!" my mother exclaimed when she saw the picture on the first page. It was the actual San Francisco police mug-shot, dated October 1910. We could not believe it.

From my parents home in Sacramento, I called historian Him Mark Lai. I told him that I was going to be in San Francisco to research my great-grandfather's past, and asked him if he could advise me. He asked for my great-grandfather's Chinese name. "It's Kwong Ming Sil," I answered. Mr. Lai did not know of him. Then I mentioned that he had tried to assassinate a Chinese government official and was sent to prison. "Oh, you mean George Lim Fong," he said casually. "Everybody knows of him." Two days later, my mother and I met Mr. Lai at the Chinese Historical Society. He gave us copies of some articles in Chinese, and a few dates of articles that had been published in the *San Francisco Chronicle*.

This is how this series of images began. Now I have newspaper articles, court documents, and prison records concerning George. Although there still are many unanswered questions and unknown avenues to pursue, I have begun the journey into my familial past. —Gavin Lee

SECRET SERVICE AGENT BLOCKS ATTEMPT TO ASSASSINATE PRINCE TSAI SUUN AT OAKLAND FERRY

George Fong, a California Born Chinese, Is Taken Into Custody and Confesses He Intended to Murder the Commissioner

AN ATTEMPT to assassinate Prince Tsai Suun, head of the Imperial Chinese Naval Commission to the United States, as he left his special train at the Oakland mole, yesterday, was frustrated by the quick wit and vigilance of Secret Service Agent Harry M. Moffitt and Detective Sergeant George McMahon, who arrested George Fong, a native born Chinese and member of the Young China party, in the act of drawing off his glove to pull a loaded revolver from his pocket.

Fong was among the large crowd which lined the station platform to greet the Prince, and but for the fact that the train failed to stop at the usual place in the train shed he would probably have been successful in his purpose.

Moffitt had been previously warned that an attempt might be made on the life of the distinguished visitor and was on the lookout, Fong having been pointed out to him as a leading member of the Young China party in this city and a suspicious character. As the train swung past the spot where it would usually stop, Fong ran with the crowd to the place where the Prince landed, and while feverishly pulling off his gloves so as to have free action was seized

and a bunch of keys were all that was found. Fong made no secret of his intentions when questioned by Moffitt, and declared that he intended to rid his country of one of its enemies. Further than this he would say nothing until after he had been closeted with the Secret Service operative for an hour in the detective office.

After a great deal of persuasion and questioning on the part of Moffitt Fong made a complete statement of his intentions, declaring that as a member of the Young China party he considered it his duty to kill the Prince and assist in the progress of the great movement to free China of the rule of Manchus. He declared that he hesitated to fire the shot on account of the large number of Americans who were in the way and might be hit, that he did not want to injure anybody but the Prince, and attributed the failure of his scheme to this cause alone.

FONG TELLS HIS STORY

When questioned at the office of Moffitt Fong told a long story of the wrongs of his country, how he had been studying its recent history, and had made up his mind to work for its cause. "I am 21 years old, and was born at 800 Dupont street. I work

t it would be used against him.

ad. A. while going over on the boat, I asked him

there on the pier with a loaded revolver. He firs

d the revolver for his protection. When I asked

s necessary for him to have a revolver at the Oakl

articular time, he hesitated and finally said he w

re to do something. I asked him what that someth

id he wanted to awaken his countrymen. Then I ask

nk if he went over there to injure any one with h

He didn't answer but kept saying he went over

hing, that he wanted to awaken his countrymen, and

if he belonged to the Young China Association. He

did and that he was a revolutionist. That was abou

of the conversation on the boat.

at time did you notice his appearance? A. Yes, si

Ivar Johnson, detail from the installation *Concerning George*
1994. Digital imagery, approx. 10 by 8 in. Courtesy of
the artist

San Francisco, July 7th, 1915.

The Honorable Board of Prison Directors,

 San Quentin, Cal.

Gentlemen:-

 In calling your attention to the parole of George Fong, which is under consideration by your Honorable Board, I desire to ask your consideration of these few facts:- This Chinese boy, is in no sense a murderer, or one who planned to murder, with the desire or longing to kill, in his heart. On the contrary, he always was one of the most peaceable, law-abiding Chinese in San Francisco.

 His position to-day, as a prisoner in San Quentin, is the result of a political plot; this boy was not the instigator of the plot, nor would he in any way have benefited by it. He, as a member of the embryotic Chinese Republic, was chosen, by lot, to commit an act against the life of a member of the, then, Royal family.

 George Fong was a patriot, although a native of California; he did not succeed in reaching the person of this Prince, and the act, which he had been selected to perpetrate, was not committed; however he saved the Government much expense, by waiving trial, and pleading guilty.

 He has served the time limit, before he could be eligible for parole; his prison record is good, as is also his entire life-record in the community in which he has lived; he has the respect and confidence of his countrymen of every position in life; and he has a family (which is being cared for by the Order of Chinese Free Masons during his imprisonment) who need his support and care.

 As this is the only time in the young man's life, that he has ever been in trouble, as there is no doubt that he will never again allow his patriotism to interfere with the Laws of this Country, I ask you to consider what possible good to the State, or to the young man, can be gained by further imprisonment?

 As we Chinese understand the Laws of imprisonment in this country, we are led to believe that a man is imprisoned to punish, and to teach him a lesson; when the State has accomplished its purpose, we do not understand the reason for then inflicting a further punishment.

 This young man will return to the outside world with a knowledge that this country protects the life and property of all who come within its boundaries; the lesson which has been taught him, will serve, for the balance of his life, to restrain him from any further transgressions, and he will have the support and encouragement of the Chinese people to sustain him in upholding and observing these laws.

 In conclusion I ask that the parole of the young man be granted and subscribe myself

 Very Respectfully, 黄甘泉

President of Ning Yung Ben Assn.,

and also President of Six Companies

Ben. Assn.

Lottery, detail from the installation *Concerning George*, 1994.
Digital imagery, approx. 8 by 8 in. Courtesy of the artist

Name _Wing Yock Shira_

Number on Passenger List (Form SG. 22) _121_

U. S. CITIZENS

Manifest Number (Form 630)

Line Number

ALIENS

Manifest Number (Form 500)

Line Number

From _HONG KONG_
(Port of Embarkation)

Destination

China Mail S. S. Co., Ltd. S. S. _CHINA_

Voyage No.

NOTICE TO PASSENGER

This slip will serve as a means of identification.

Upon arrival at San Francisco, immediately after the Quarantine Doctors' inspection, present this slip to an Immigration Officer in the Dining Saloon. Every passenger on board must appear before one of these officials, so please BE PROMPT, to avoid delay in disembarkation.

Form 279A

Jade Cicada, detail from the installation *Concerning George*, 1994. Digital imagery, approx. 8 by 10 in. Courtesy of the artist

Installation view of *Concerning George*, 1994. Digital imagery, mixed media installation, approx. 3 by 9 by 3½ ft. overall. Courtesy of the artist

Facing page: *S.S. China*, detail from the installation *Concerning George*, 1994. Digital imagery, approx. 10 by 8 in. Courtesy of the artist

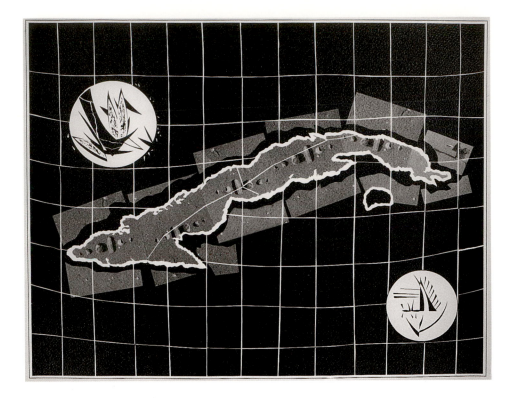

MARÍA MARTÍNEZ-CAÑAS

MARÍA MARTÍNEZ-CAÑAS

In 1979, MY SISTER ELENI gave me a small book that contained four sets of Cuban stamps. The first three sets depicted animals, planes, and ships. The fourth set consisted of six stamps that reproduced the works of Cuban painter Amelia Peláez. Because I am an admirer of Amelia's work, I was very happy to see Cuban stamps honoring this great artist. I soon began collecting Cuban stamps, and it has become another element, another memory, another key, to a better understanding of my roots.

A stamp is something that is used to send, to dispatch, to bring news; it suggests the idea of a journey, of physical travel. If a map is used to find and locate, then a stamp is used to send, separate, deliver, and to bring closer and reconcile. In this way, these stamps became an essential instrument in coming closer to a personal sense of my Cuban identity. —María Martínez-Cañas

Primavera, Jorge Arche, from the portfolio *Quince Sellos Cubanos/Fifteen Cuban Stamps*, 1991. Collaged gelatin silver prints, 20 by 16 in., with original Cuban postage stamp, 1967, approx. 1 by 1 in. Courtesy of the artist and Catherine Edelman Gallery, Chicago

Facing page: *Cuba 4 Centavos*, from the portfolio *Quince Sellos Cubanos/Fifteen Cuban Stamps*, 1991. Collaged gelatin silver prints, 20 by 16 in., with original Cuban postage stamp, 1958, approx. 1 by 1 in. Courtesy of the artist and Catherine Edelman Gallery, Chicago

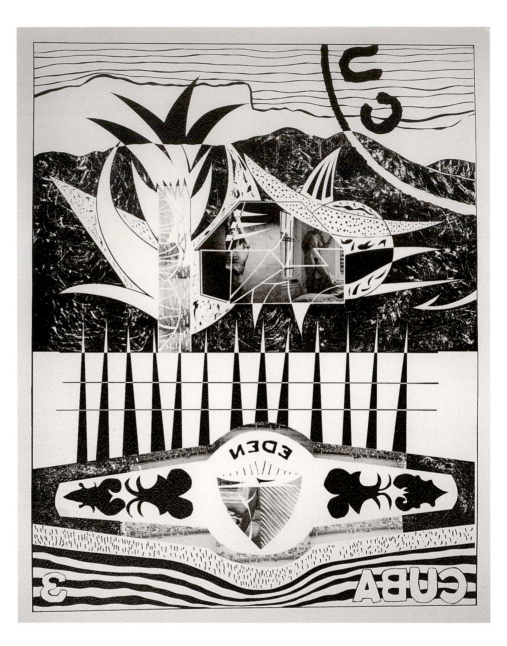

Eden, from the portfolio *Quince Sellos Cubanos/Fifteen Cuban Stamps*, 1991. Collaged gelatin silver prints, 20 by 16 in., with original Cuban postage stamp, 1970, approx. 1 by 1 in. Courtesy of the artist and Catherine Edelman Gallery, Chicago

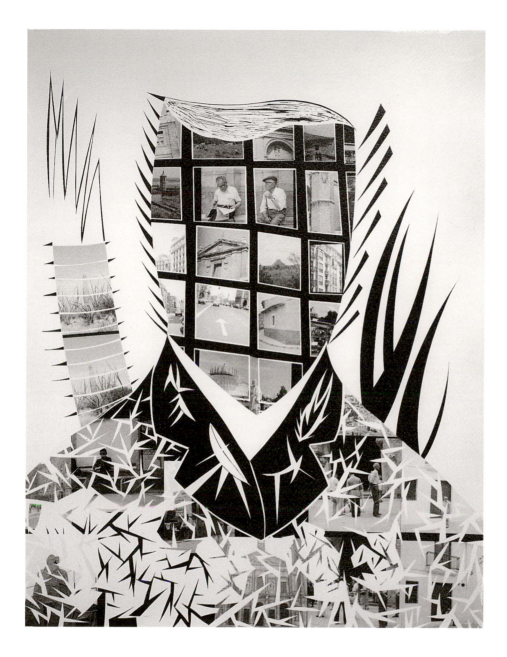

Centario Nacimiento General José Maceo, from the portfolio
Quince Sellos Cubanos/Fifteen Cuban Stamps, 1991. Collaged
gelatin silver prints, 20 by 16 in., with original Cuban
postage stamp, 1952, approx. 1 by 1 in. Courtesy of the
artist and Catherine Edelman Gallery, Chicago

RUBÉN ORTÍZ TORRES

To me, the saddest thing in America is the lack of a place for mulatto peoples. It's not like in Cuba, say, or in Brazil. In America, if your father is black, *you're* black. In my work, I like to think about new identities and look at what's really happening among different places and cultures. Ties and tensions—whether among the United States and Mexico, or Chicanos and Chilangos—reflect enormous changes. For me, change is the reality of trying to be both Mexican and international.
—Rubén Ortíz Torres

Graceland Apparition/El Vez, Los Angeles, California, 1991.
Chromogenic print, 20 by 24 in. Courtesy of the artist
and Jan Kesner Gallery, Los Angeles

Facing page: *Mexican Sombreros, Los Angeles, California,*
1991. Chromogenic print, 20 by 24 in. Courtesy of the
artist and Jan Kesner Gallery, Los Angeles

Venderemos/Sandino & Mickey in a Restaurant, Mexico City, Mexico, 1991. Chromogenic print, 20 by 24 in. Courtesy of the artist and Jan Kesner Gallery, Los Angeles

Ducktales/Pataoventuras, Mexico City, Mexico, 1991. Chromogenic print, 20 by 24 in. Courtesy of the artist and Jan Kesner Gallery, Los Angeles

Facing page: *Santo Niño/Holy Kid, Guanajuato, Mexico,* 1991. Chromogenic print, 24 by 20 in. Courtesy of the artist and Jan Kesner Gallery, Los Angeles

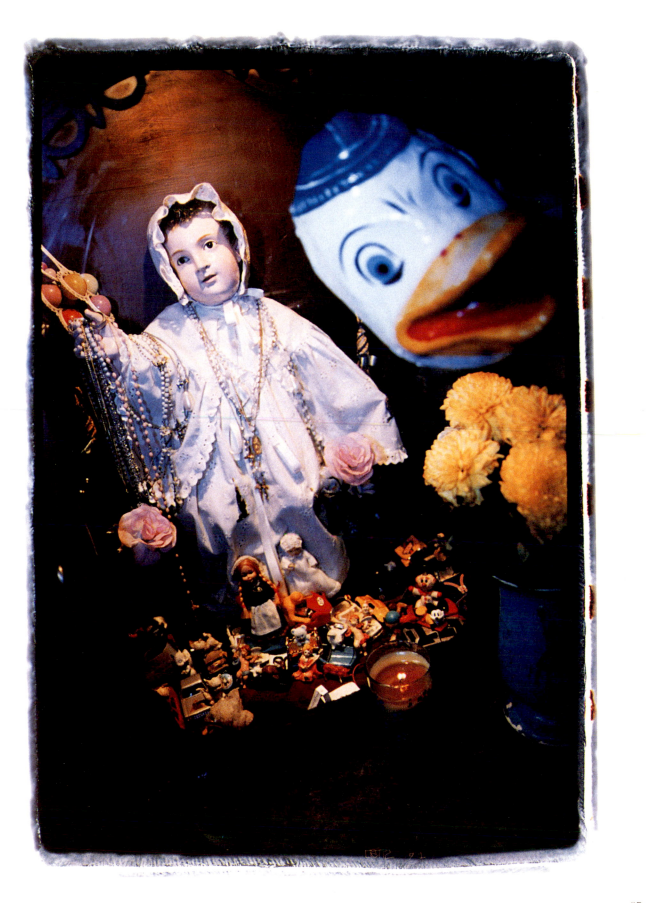

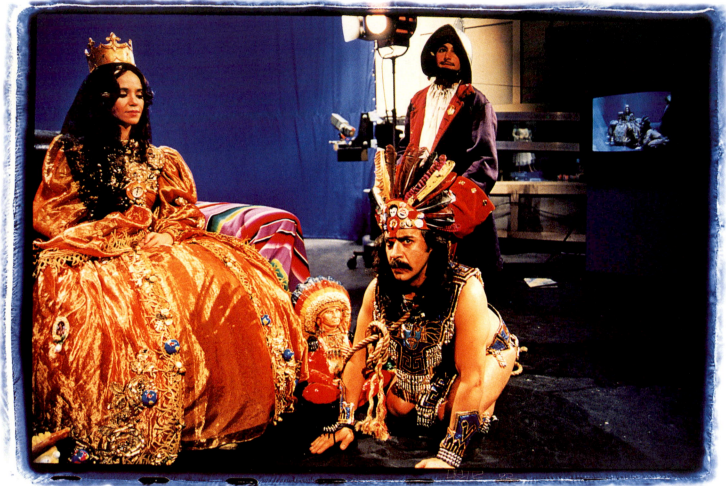

500 Years After / 500 Años Después, Valencia, California,
1992. Chromogenic print, 20 by 24 in. Courtesy of the
artist and Jan Kesner Gallery, Los Angeles

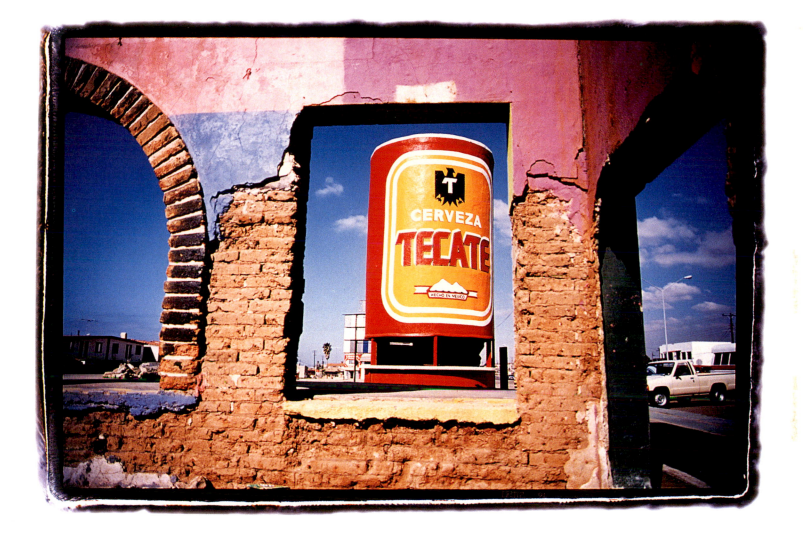

Made in Mexico, Rosarito, Baja California, 1991. Chromogenic print, 20 by 24 in. Courtesy of the artist and Jan Kesner Gallery, Los Angeles

CARRIE MAE WEEMS

I HEARD SOMETHING RECENTLY THAT UPSETS ME every time I think about it: there are no stories of the middle passage. One hundred million people were stolen and sold from their homes, shipped across the world, and not a single story of that journey survives. The very idea puts me up and over the top. We know what happened before these people were shipped to America, and we damn sho know what happened after, but we know nothing of the *during*, not one single story.

I've always been interested in searching for my African ancestry outside of an American context. I know about Africanisms maintaining themselves in the United States—in language and style and dress and dance and so forth—but how do Africanisms maintain themselves in Africa? I wanted to see.

When I began to photograph in Africa, I was thinking, *how does a community, a culture, shape itself? What are the signs of its belief system?* But then I shifted a bit and decided to focus on the slave coast, its look, scale, and dimension. I wanted to see and feel where the slaves were kept and under what conditions. I began to see the imprint of various cultures—Portuguese, English, Dutch—on the architecture of slavery.

I went to Goree Island, this little tropical haven in the middle of the ocean. From this place—this beautiful, light, airy place—the most horrific crime of the seventeenth, eighteenth, and nineteenth centuries occurred. One hundred million Africans were shipped from this place, but only twenty-two million survived the passage. Imagine that. Goree Island is like Auschwitz. The comparison is one way people can begin to comprehend the significance of what took place there.

I'm interested in playing the formal grace of the architectural elegance of Goree with the horror that went on just beneath the surface. For the first time I'm beginning to sense the meaning of architecture. On Goree and Cape Coast, for example, beautiful spiraling staircases led down to dungeons. The images are seductive, they invite you right on in. But the photographs also ask you to question the relationship between the formal beauty of the places that are depicted and the horrific reality of what happened in these places. The text does this also: *Grabbing, snatching, blink, and you be gone.*

Okay, this is what it is, what it looks like, what surrounds it. For me, having a sense of it is very important. I mean, since millions were shipped from this bad-boy, there's a good possibility that my great-greatmomma began her long journey from this place. I've finally discovered something real about my historical past, and thus my present situation.—Carrie Mae Weems

CONGO
IBO
MANDINGO
TOGO

Untitled, from the series *Africa*, 1993. Gelatin silver
print, text, 20 by 40 in. overall. Courtesy of the artist
and P.P.O.W., New York

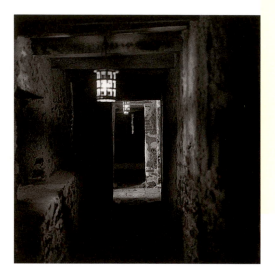

GRABBING
SNATCHING
BLINK
AND YOU
BE GONE

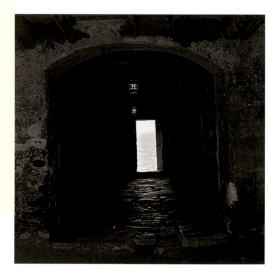

Untitled, from the series *Africa*, 1993. Gelatin silver
prints, text, 25 by 60 in. overall. Courtesy of the artist
and P.P.O.W., New York

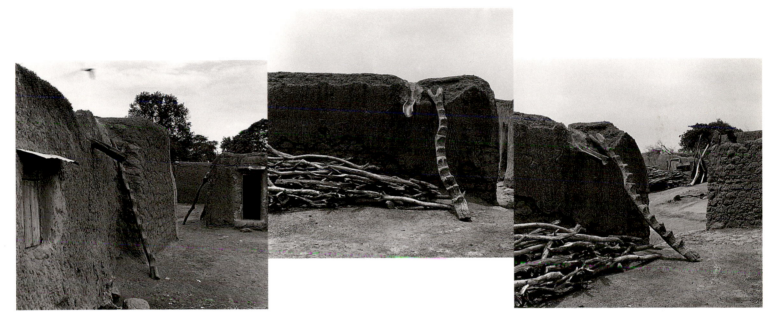

Untitled, from the series *Africa*, 1993. Gelatin silver
prints, 25 by 60 in. overall. Courtesy of the artist and
P.P.O.W., New York

Untitled, from the series *Africa*, 1993. Gelatin silver prints, text, 60 by 20 in. overall. Courtesy of the artist and P.P.O.W., New York

Facing page: text panel, from the series *Africa*, 1993. 20 by 20 in. Courtesy of the artist and P.P.O.W., New York

ELMINA
CAPE COAST
IIE DE GOREE

LIVING IN AN URBAN CENTER SUCH AS LOS ANGELES, I find that being Asian American is, in many respects, part of a pervasive phenomenon. Minority and interracial identity have become prevalent features of West Coast culture. Twenty years ago, my otherness as an Asian of mixed origin might have posed certain problems; indeed, I would have been marginalized from both white and Japanese culture. Now, I find myself among people who are comfortable in the indeterminate space outside of "pure" race. This (n)either/(n)or position allows for a tremendous amount of freedom and mobility to move between categories. It is a fluidity that allows me to constantly redefine my position as an individual and an artist. Although I embrace this attitude, I find that others are not as comfortable with it. They wish to affiliate me definitively as Japanese American rather than with a more complex identity.

My work as an installation artist assumes a similar position of ambiguity through its attempt to complicate borders. I have this fantastic notion that the environments I create permit the psychological space within the envelope of my body to pass through my skin and become a physical realm in the world, thus diffusing the borders of identity between myself and others.

Memory and amnesia elicit the meaning and form of my work. In the absence of a biological history, I am at liberty to reconstruct my past as an exercise in fiction. Without an allegiance to known origins, I have the privilege of embracing a temporal heritage, one that is in a constant state of redefinition.

There has been a pervasive resurgence of identity politics within the art world in the past decade. Even more recently, I sense an equally reactionary counter-response. Although a multitude of artists currently are making work about their identity and otherness, the subject has not always been thoroughly convincing or engaging to the dominant culture that continues to regulate access. This comes out of the need for revision in both artistic and curatorial practices, in order to develop more complex models of identity beyond the categorical existence of race and representation. By not expanding upon the complicated relationship between production, institution, and reception, the intersection between art practice and identity politics has been generalized to a very narrow venue. —Kim Yasuda

She Was Both, from the installation *Hereditary Memories*, 1991. Mixed media, approx. 4 by 12 by 20 in. overall. Courtesy of the artist

I. DAISY CHAINS

BY REBECCA SOLNIT

THINGS IN MY FAMILY have a way of disappearing. My father's baby sister—my beautiful black-haired aunt—once showed me a whole box of family photographs, and the blank wall that lay behind my own beginnings gave way under a cascade of cardboard-mounted formal poses and strange unnamed faces in all the range from sepia to gelatin-silver gray. The one I remember best from all those years ago was of my grandmother and her two younger brothers at Ellis Island, or at least from around the time they came through Ellis Island. They were lined up in an overlapping row according to height and the conventions of the era's portrait photography. Their heads had been shaved for ringworm, and they had the hollow-eyed, underfed, haunted look of so many Jews of the time, these three bald children in their matching white sailor suits who had got themselves all the way across Europe and the Atlantic, and were about to cross another continent alone. When I asked about the photographs later on, my aunt said that the box of images— and with it the abundance and clarity of our past—didn't exist, and I must have imagined the whole thing. Last time I asked, she said the box existed but had vanished.

Photographs, which are supposed to serve as the anchors of an objective past, are as unstable as everything else that constitutes my paternal family history of myths, contradictions, and silences. (It's a kind of family history that is, I suspect, more common than the reliable family histories that dominate literature.) I have rarely heard the same story twice, and if I repeated a story I remembered, it was denied or retold in a completely different version. In some ways this family history resembles, on a small scale, Eastern European history itself, in which countries are devoured and regurgitated by empires, borders fluctuate in disregard to language and culture, in which purges and pogroms eliminate factions and populations, in

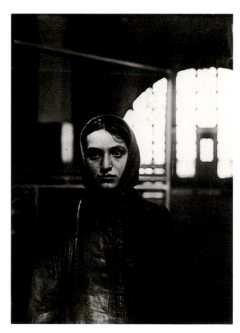

Lewis Hine, *Young Russian Jewess at Ellis Island, 1905.* Gelatin silver print, 6 1/2 in. by 9 1/8 in. Courtesy George Eastman House

which the past was suppressed with the aid of an airbrushed photograph, so that images keep pace with the times and those who disappeared from the world also disappear from the pictures of it.

It may be, too, that truth itself was not a fixed quantity for my family, poured as it was back and forth from the various languages they spoke, just as emigration didn't constitute the same kind of displacement for people whose diaspora had begun so long before. The father of the children with the shaved heads, my great-grandfather, had emigrated early in this century from Bialystok, which had long ago been Lithuania, then Poland, was once held by Napoleon's troops, was Russia during the time of their emigrations, a war zone between Germany and Russia in the first World War, occupied by the Red Army in 1918, then nationalist Poland, which was occupied by the Germans who would make both the Jews and their artifacts virtually disappear. The disappeared include, so far as I know, all but one member of my family who didn't emigrate. And so the city sat through fluctuating definitions, through the Communist era and into resurgent nationalist Poland, with its now diminutive Jewish population. This is not to say these ancestors of mine were Russian, or Polish, though Jews had been in Bialystok since 1548. At home they spoke the medieval German dialect Yiddish, though they weren't German either, but the children of the diaspora that had begun in Israel/Palestine almost two millenia before. Another lan-

guage, Hebrew, was preserved for other uses; and an indelible image of a then-imaginary homeland kept its speakers from melting into their surroundings.

My grandmother's mother disappeared too. The three bald children probably didn't know they were already motherless at the time of the photograph, though they hadn't seen either parent in many years. As was the tradition, their emigrant father sent for his wife and then his children as he established himself in the New World—in Los Angeles, to be exact, which had for a while the second-largest immigrant Jewish population in the U.S. Or that's what I was once told, when I was told that my great-grandmother disappeared somewhere between Eastern Europe and the American West. I used to imagine all the things that could happen between the two places, picture her getting off a train somewhere on the prairie, getting lost and staying lost, starting up an unimaginable new life unlike the one allotted to her by her family, stepping out of the turbulence of an Isaac Bashevis Singer story into the calm of a Willa Cather novel.

For a long time, I imagined that the woman in Lewis Hine's 1905 photograph *Young Russian Jewess at Ellis Island* was my mysterious great-grandmother; and if I could have believed it long enough and well, I might have assimilated it into my family history, or mythology. It's a strange image, one that seems to have drifted across the history of photography. Made by Hine during the turn-of-the-century debate over immigration, it was seized

upon by Beaumont Newhall as an example of documentary-in-the-abstract for his *History of Photography*, though it would be hard to say what it documents nowadays beyond a brooding, intense face in an indistinct, soft-focus background. It would make more sense as pictorialism, since it's less about information than mood. A woman with a scarf or shawl pushed back just far enough to show her dark hair, parted in the middle and not very recently washed, looks at something past the camera, neither intimidated nor engaged with it. Only her cloth coat with its asymmetrical closure places her as being from the far eastern fringes of Europe.

Up close she is nearly beautiful, but from further away you can see the skull in the set face of this emigrant, as though through hunger, exhaustion, fear she is close to other borders besides the national ones. Above her shadowed eye-sockets, her forehead gleams as white as the sky behind her. It's as though we can see through it to the same distant pallor of the sky, or as though both are only absences on the paper, a forehead and a sky that imparted no silver to the print. Ellis Island, which in most photographs appears so overrun by people, is empty and still here. The only thing that seems specific to that island of emigration are the bars behind her, which seem to be the fenced walkways through which lines of people were processed, but there is no one in them in this picture. This image of such a private and solitary moment in the packed bustle of Ellis Island is a document of an anomaly. Another

impact is in the title, *Young Russian Jewess at Ellis Island*, a novel in one sentence about a particularly vulnerable person poised between two worlds, pinioned by history.

Later on, the story about my great-grandmother's disappearance was revised: I was told that her husband had had her committed to an insane asylum as soon as she arrived, perhaps to get her out of the way. When my grandmother emigrated to Los Angeles some years after her mother had departed Russia, her father—my great-grandfather—was remarried and had another daughter, young, adorable, English-speaking. My grandmother grew up, learned English (though she spoke it with a heavy Yiddish accent for the rest of her life), and joined, according to another photograph, a ladies' hiking club: stalwart young women in knee-high lace-up boots and bloomers so uniform they look like a military group. She married another immigrant from a nearby town in the Russian pale sometime in the latter 1920s, my grandfather, who was brought over by his older brother after he was caught up in the throes of the Russian Revolution. He had survived the turmoil of the revolution by smuggling food across the Russian-Polish border, had once been badly beaten by the Polish border guards and another time escaped detection by joining the Red Army, where he was supposed to have been Trotsky's flag boy. Or so I was told. I've always had the impression that he was so small—which I know from photographs and stories; I only met him once—was because of

malnutrition, since my father, fed upon California's bounty by a doting mother, was a foot taller than him.

My grandfather's older sister, my father told me, was shellshocked by the pogroms and wars she'd lived through in Brestlitovsk, and never left her L.A. house without a large bag of fruit, as provisions in case a disaster suddenly broke out around her again. When she babysat him, rather than tell him bedtime stories she showed

THIS IS HOW ONE PICTURES THE ANGEL OF HISTORY. HIS FACE IS TURNED TOWARD THE PAST. WHERE WE PERCEIVE A CHAIN OF EVENTS, HE SEES ONE SINGLE CATASTROPHE WHICH KEEPS PILING WRECKAGE UPON WRECKAGE AND HURLS IT IN FRONT OF HIS FEET. THE ANGEL WOULD LIKE TO STAY, AWAKEN THE DEAD, AND MAKE WHOLE WHAT HAS BEEN SMASHED. BUT A STORM IS BLOWING FROM PARADISE; IT HAS GOT CAUGHT IN HIS WINGS WITH SUCH VIOLENCE THAT THE ANGEL CAN NO LONGER CLOSE THEM. . . . THIS STORM IS WHAT WE CALL PROGRESS. —WALTER BENJAMIN[1]

him the fruits and named them again and again until he fell asleep. Maybe this is my real history, a narrative of paradise: the circular litany of the surety of food and the names of the fruits in an as-yet smogless Los Angeles amid the orange groves and mountains. Maybe Nuestra Señora la Reina de Los Angeles, after whom the city was named, is the Angel of History in this particular private history, the angel from Walter Benjamin's ninth thesis of history, that angel who cannot close his wings or make whole what has been smashed, because a storm is blowing from Paradise and the wreckage is mounting skyward.[1]

The brother of this fruit-carrier, my grandfather, was a rogue and a gambler. Later in his life, after he had divorced and moved to El Paso,

he became a border smuggler again, though this time Mexican housewives carried the goods. My father never talked about all this. I can count three stories he told me about his family and childhood. He was tall and blue-eyed, slender and fair-haired through his twenties (though not in my time), seldom taken for a Jew in a society whose anti-Semites knew what Jews looked like. He was part of that great

IT MAY BE ARGUED THAT THE PAST IS A COUNTRY FROM WHICH WE HAVE ALL EMI-GRATED, AND THAT ITS LOSS IS PART OF OUR COMMON HUMANITY. —SALMAN RUSHDIE

universalizing, assimilationist wave of the 1950s that thought the past was unnecessary baggage, ethnicity something that would disappear into the melting pot of America, if it hadn't been checked at the gates of Ellis Island. My father's younger sister, my aunt, was as dark as her mother, and when she lived with her father in El Paso she was routinely suspected of being an illegal alien. She had to emigrate over and over again from Juarez, and since she acquired a Spanish name from her second husband many people have assumed she is Hispanic. She has been the keeper of the family stories and photographs, though they have served less as buttresses of a stable sense of the past than as phantasms and fictions that metamorphose continually in accordance with the needs of the present — but all histories and photographs do that, public as well as private.

Another time, my aunt had hung a picture of her mother, my grandmoth-

er, in her house, another image I saw only once. It showed a child standing next to some rough-hewn wooden farm implement. Had photography existed five hundred years ago, it wouldn't have been hard to imagine this to be a photograph from that time. It conveyed how backward, how almost medieval, was the world from which my grandmother came, when she came to the sunny, optimistic boomtown of Los Angeles in the teens or twenties. My grandmother was supposed to have been a paranoid schizophrenic. That was the diagnosis she was institutionalized with during the last decades of her life. I always thought, even before I saw the picture of her in medieval Europe, that her world-view might have been perfectly reasonable under the circumstances. The doctors who treated her were unlikely to have experienced such profound instability: disappearing mothers, the vast gap between medieval Bialystok and glittering Los Angeles, the three or four languages she lost and the English she never completely acquired, the almost complete annihilation of the world she came from and the relatives she left behind. As the body completely replaces itself on a molecular level every seven years, so the world seems to replace itself in its essentials every generation, with what survives recontextualized as antiques, relics, ruins — the bones of an unrevivable past. In my grandmother's case, everything changed more quickly and violently.

The people in the photographs my aunt sometimes showed me seemed to have little or nothing to do with me;

their faces, their poses, their clothes spoke more of time and place than of family and resemblances. The technology and conventions of photography have given a particular look to each generation's images, while history, fashion, and food have left their impressions on everyone, so that nearly everyone in a given era has a kind of kinship to each other they don't to other generations. Before the 1960s, light and air themselves seem to have had an almost undersea depth and luminosity, in which skin glowed opalescently and everything had a faint aura slaughtered by the newer, flatter films. I think most Americans who didn't live through it think the Depression took place in a world of roughhewn but secretly seductive black-and-white surfaces, think that the early part of the century was full of hollow-socketed stern faces above body-belying clothes, with everyone up against a wall somewhere. This is the world of those apparitional photographs of what doesn't look like my family.

It isn't only an immigrant story. My friends Mary and Carrie Dann, Western Shoshone land-rights activists who ranch on the land their father ranched in the unrecognized sovereign nation of Newe Sogobia, have two handsome hand-tinted oval photographs of the grandmother who raised them hanging on the ranch house wall. They tell me this grandmother, whose memory stretched back almost to the time before whites invaded their part of Nevada, never slept in a bed, never lived in a board house. The photographs of this woman in robes sitting tranquilly in front of her wickiup in a scratchy atmosphere now face a television, a VCR, and a bank of those smooth color portraits from schools and department stores. Salman Rushdie once remarked, "It may be argued that the past is a country from which we have all emigrated, and that its loss is part of our common humanity," but went on to say that such a universal displacement paled before the situation of emigrants from languages and countries.[2] There are cases, such as the Danns', where the world and the borders have changed around them; some immigrants didn't have to move.

My paternal grandmother appeared in my life as abruptly as her mother must have disappeared. No one mentioned to me that I had a grandmother other than my mother's charming Irish American parent in New York until one day on a trip to Los Angeles, when I was about six. We drove up to a tall cement building in a sea of concrete, and this unanticipated ancestor came down and kissed me. She left a smear of lipstick on my cheek, and my mother turned around and gave a little scream because she thought it was blood. Later on, my grandmother was transferred to the state mental hospital in Napa, not far from where we lived. For years I thought it was a retirement home, because she was on a ward populated entirely by elderly women thirsty for the sight of children, who used to flock around us and give us coins when we visited, and because no one told me otherwise. It was an uncannily tranquil place full of broad lawns scattered with trees casting pleasant shade around them, the place where Carleton Watkins spent his last years and is buried, almost the only place he went that he didn't photograph. Only rarely did a shriek pierce the calm. When I try to recall it now I remember the redwing blackbirds we used to see in the San Pablo Bay marshes on our way there; and an afternoon or many afternoons my younger brother and I spent on one of the lawns there making daisy chains, which my grandmother wore till they were wilted around her vast bosom and hunched back; and I remember the cherry cider stand under a huge tree we used to stop at on the way home, and the taste of cherries. It never occurred to me to ask her about the past, and she probably wouldn't have had much to say, because electroshock tends to destroy memory. I can only surmise that she was, like her mother, an internal exile from the nightmare of history.

A few years ago, one of my brothers visited our cousins in Mexico City. These were our grandmother's first cousins with whom she had stayed after her parents had emigrated, and who emigrated to Mexico when she came to the U.S. The patriarch of that family, who had started out as a street peddler and become a wealthy art collector, remembered their childhood together in Bialystok and told my brother that our great-grandmother had never reached Ellis Island and the U.S. at all, but had been put in an asylum in Russia. When I heard that story, the image of the *Young Russian Jewess at Ellis Island*

Albert Chong, Untitled (Throne with Crucifix, Water and Dreadlocks), 1991. Gelatin silver print, 24 by 20 in. Courtesy of the artist

this: a studio photograph of a handsome plump boy sitting with one foot tucked under the other leg, visibly flaxen-haired and golden-skinned even in black and white. My aunt gave it to me after he died. Perhaps it's the double-breasted, shortsleeved jacket he wears, too old a style for a child; perhaps it's something already hard and joyless in his face; or perhaps it's an intimation in this child's pretty face of the person he was becoming that makes the image so terrifying to me. There's a romantic tradition of looking at ruins in which the crumbled remains of what once was mighty produces a satisfactory sense of the unstable and fleeting nature of power—a tradition of looking after the event. Images before the event, before the occasion of power, possess another sense of instability, in which other outcomes are still possible, images in which we can see the raw material of our own destinies before they have taken form. The present is the fruit of tiny events, each one decisive, each one eliminating the countless other presents that might have been, and a photograph of the past is a photograph of a time at which those outcomes were yet indeterminate.

suddenly vanished from my imaginary family album and became an impersonal image, a Lewis Hine image from the world called documentary, and the nameless woman from whom I'm descended became faceless and unimaginable again.

II: BLONDE JESUS
A PHOTOGRAPH OF MY FATHER as a child of about two watches my back when I write and watches as I write

When I was a child, my father told me a story he must have been told himself, for there is no way he could have remembered it. It goes like this. When he was a small child in East L.A., his parents used to go out dancing on Saturday evenings, when the Sabbath sun had set. One time they went out as usual and left him with a babysitter, this time a Seventh-Day

Adventist whose lesson that day had been on the Second Coming. Presumably nurtured on bible cards of a fair and cherubic Christ child, she recognized the flourishing blonde baby my father was as Jesus born again among the Jews, and so she decided to take it upon herself to postpone the end of the world that would follow upon His return. (It was never clear why this particular Christian thought the end of the world so unfortunate, but I always assumed it had something to do with the booming Los Angeles real estate market and the aggressive optimism of the time, on the cusp of the Depression.) She pulled a sofa up to the oven, turned on the gas, gathered up the child, gave him his bottle, and settled in to await their end. When my grandparents came home unexpectedly early, sitter and child were peaceably drifting toward oblivion. And so, among the infinite coincidences and incidents to which I owe my existence is, perhaps, a dance that didn't keep my grandparents late circa 1930.

After that, the story concluded, they used Jewish babysitters. It's then that Great-aunt Verka and her burden of fruit comes in. Whether this thwarted little infanticide happened or not, it suggests the profound suspicion that my grandparents and father had of the world around them. The story seems to propose that in such a bizarre world, though looking like a Jew was supposed to be dangerous, so might not looking like one. In Franz Kafka's *Amerika*, the emigrants sail into New York harbor to see the Statue of Liberty hold-

ing upright not a torch but a sword; the country my grandparents lived in seemed to be governed by that goddess with her stern and absurd weapon. It was an angel with a flaming sword who barred Adam and Eve from Paradise; this version of Liberty seems to be a goddess of exile as much as of refuge, and of enforcement, violence, and unpredictability. Maybe it's here that Nuestra Señora la Reina de Los Angeles becomes the Angel of History, in this violent version of liberty.

Though it was told as comedy, the story of the babysitter is one of the few overt instructions I received in a worldview that was otherwise transmitted by more nebulous means; a worldview compounded of a sense of the absurd, a suspiciousness of dominant culture, authority, institutions, a lack of the sense of stability and centrality that I have always suspected of being the main advantage of being mainstream, though we became privileged enough.

Like Kafka's *Metamorphosis*, the story of my father's Christian babysitter is a story of familial transformation; the babysitter recognized how unlike his parents my father was—recognized that we were turning into something else, if not exactly cockroaches or saviors. The melting pot was never adequate to describe what happened to anyone besides European immigrants, but it was an alchemists' crucible in the imagination of that time into which so-called ethnic Europeans were tossed, their children emerging as white Americans, people whose identity was sup-

posed to lie in the marvelous future, not the painful past. Maybe all the silences in my family history were meant to aid our progress; jettisoning the past has always been a popular way of trying to embrace the future. But having abandoned the world he was supposed to belong to, my father never found another one to join, save for the vague sureties of the middle class. An isolated figure, he became among other things a great traveller who worked as an urban planner in Peru, Micronesia, Israel, and seemed to find in travel a palliative to the alienation that is so bitter at home yet so pleasant and appropriate abroad. Travellers know that one can seek refuge from exile. He's buried in Israel, ironically enough, in an unmarked grave, but that's another story.

After his death, my aunt told me that my father had followed World War II in Europe with obsessive intensity. They'd had to share a room in which his side was dominated by an enormous map with push-pins representing the Axis and Allied troops, and that in a kind of dress rehearsal for his later reign of terror, he'd held her culpable and punished her whenever a pin fell off. During my childhood, he assembled what must have been almost the entire fleet of World War II battleships out of those plastic kits that were everywhere in the sixties, and the same heavy hand awaited any of us who disturbed the ships which, once they were assembled, sat on shelves gathering dust. This was as close a response to the Holocaust as I ever

saw him make, this obsession with the minutia of the war. My father was profoundly ambiguous about being a Jew, and wanted to leave his past far behind; his observances as an adult extended little farther than refusing to have a Christmas tree in the house, and he liked the trappings of Christian western Europe: coats of arms, ancestral estates and, presumably, my Irish Catholic mother.

Such a parentage made us Jews only in the eyes of Christians and vice-versa, made us vastly different from our parents who were raised in ethnic enclaves, meant that there was no going back to an uncluttered monoculture. But we did become white, an idea whose meaning is contextual. In Europe, where everyone was nominally white until the colonized of Africa and Asia started emigrating to the colonizing nations, hatred was portioned out according to other criteria. During my father's time, Jews had begun to enter the institutions of power and culture in the U.S., opening up a breach that the Civil Rights, feminist, and many movements since would broaden into at least a back door into those castles. As Cornel West remarked, "This Jewish entrée into the anti-Semitic and patriarchial critical discourse of the exclusivist institutions of American culture intiated the slow but sure undoing of the male WASP cultural hegemony and homogeneity."[3] By my time, not much more than attitude—an affinity for outsiders, eccentrics, and rebels—set us apart from the mainstream.

When I say we became white, I mean it literally too. Through a triumph of recessive genes I became absurdly, literally, white—whiter than anyone on either side of the family, with the marble skin of my mother's family and the blonde hair of my father. My mother, dark-haired since infancy, never quite believed that my hair was really so fair and always instructed me that it was on the verge of turning dark, as my brothers' hair eventually did. She used to save little packets of it so we could see what it once was, though when she recently pulled out a packet from when I was five, the pale strands it contained were indistinguishable from the sun-bleached ends of my current crop of hair. Still, she gave me a lack of faith that this known quantity would continue to come forth as it has—an interminably slow cascade of muddy gold—and a reluctance to cut it. I saved the long braid that I cut off when I got a punk haircut at twenty, and saved the lesser leavings for a long time, fascinated by these creations of the body neither living nor dead, detached and somehow still myself, souvenirs of the bodily past. Hair is a repository of power, and hair lost and hair left to grow are serious business, from the shorn heads of orthodox Jewish brides to the never-cut locks of Sikh warriors. I met a woman once, when I was puzzling it all out, who said she'd had a job the year before photographing students at a Native American school in New Mexico. One of the girls she photographed told her of having her own braids cut off; she was ashamed

to go home afterward, and when she did, her grandfather chided her gently, telling her that her hair contained all her thoughts and memories. The French used to shave the heads of sorcerers, and after World War II they shaved the heads of women who cohabited with German soldiers.

During my childhood I was fascinated by stories of the Holocaust, by those accounts of perilous escapes and hideous ends. There were a lot of cheap paperbacks for children in circulation about that era. I remember one about children of indistinct ethnicity fleeing across Germany and living on cabbage leaves; another about Jews in some kind of Siberian camp which recounted details of deprivation such as letters written between the lines of books and newspapers; Ann Frank's diaries of the tense uneventfulness of her years in hiding; and a book my aunt, the same aunt, gave me. A vastly literate English teacher, she sent like missiles and life rafts serious books into my childhood: Kafka at ten, Borges at twelve. At eleven, it was Jerzy Kosinski's vaguely autobiographical tale *The Painted Bird*, about a small child's ghastly odyssey across rural Poland during World War II. Again and again in *The Painted Bird* the brutish, fair-haired Poles would recognize the dark child as a Jew or Gypsy, persecute him or drive him on across a countryside that seemed to be less the realm of the mid-twentieth century than the backdrop to a medieval Temptations of St. Anthony, or a Breugel painting of drunken peasants. I used to conjure up scenarios in which I was adrift in Axis Europe

and wonder if, with the fair hair I inherited from my father, I could have slipped out of the Nazis' net, could have assumed another identity, passed as a gentile, pure and simple. It became an obsessive daydream in which fear was countered with innumerable inventive escapes and disguises.

One evening about five years ago, I saw a program on my old black and white television about a group of Jews making a pilgrimage to the concentration camps of eastern Europe. There were puddles on the ground, and the wind blew; as it tugged at their clothes, survivors spoke of memory, others of the necessity of history. One camp had been preserved exactly as it had been at the end of the war, and the somber-faced visitants filed through its gas chambers and the dim concrete passages of its storerooms and barracks. At this camp, said the voiceover, an effort had been made to find a use for all the byproducts of genocide, and the camera plunged into a square concrete room knee-deep in dark hair, a single shadowy mass except for, suddenly in the far corner, a long blonde braid, which looked in that piercing glimpse terribly like my own.

III: A RIPE PEAR

THE IMAGE I'VE BEEN THINKING ABOUT most lately is a map, a map of North America in 1819, from the even more nebulous past before the last century-and-a-half of photography. Like the baby picture of my father, the map is an image in which

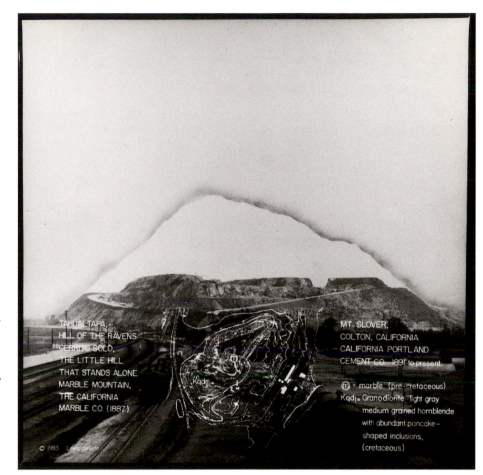

Lewis deSoto, *Slover Codex,* from the installation *Tahualtapa (Hill of the Ravens),* 1987–1988. Gelatin silver print with text, 42 by 42 in. Collection of the Seattle Art Museum, gift of the artist

innumerable other futures hover around the edges. At that point in time, space was different, or at least the imaginary lines drawn across it were: California, Nevada, Utah, Arizona, New Mexico, half Colorado, and most of Texas were still northern Mexico and nobody's southwest. It was with the seizure of this land that the U.S. acquired a neighbor to the south, acquired a landscape whose place-names are still predominantly Spanish and whose topographical features—playas, arroyos, mesas— can't be named in English. It was with this taking and the 1846 agreement on

Oregon Territory that the U.S. became a coast-to-coast nation with the dimensions, ambitions, and resources of an empire, an emerging world power. In the map of 1819, the present we inhabit has not yet been singled out from the countless hovering futures.

The stories I've been telling are stories within an east-west narrative, the narrative of European emigration to America, a narrative that shaped my grandparents and imprinted my father's life, a narrative that has blown like one cloud into the stormy weather of California. I may be the product of that narrative, but I seem nowadays to reside in another one, the north-south narrative that increasingly determines California's meanings, conflicts, and future—a narrative as full of silences and the disappeared as any my family has. In this new trajectory I am relatively privileged and established, though still in an unsettled region that will, within the next few decades, recontextualize everyone who remains.

When I wrote of my grandmother in the mental hospital, it was the redwing blackbirds and Bing cherries that came back most vividly to me. The unreliability of my family history, the sense of coming out of half-forgotten misty horror, has been counterbalanced by the bright immediacy of the landscape I have spent nearly all my life in and know so well, which in some sense supplanted family as the ground of my identity. Between the two of them, with their omissions and myths, there was enough buried to make me a historian, someone pre-

occupied with salvaging and reconstructing versions of the past. And in between the displacements of emigrants and refugees and the abstractions of nationalism seems to be landscape, a literal ground for identity and interpretation. One of the thoughtful exiles of our time, Edward Said, wrote, "A generation ago, Simone Weil posed the dilemma of exile as concisely as it has ever been expressed. 'To be rooted,' she said, 'is perhaps the most important and least recognized need of the human soul.' Yet Weil also saw that most remedies for uprootedness in this era of world wars, deportations, and mass exterminations are almost as dangerous as what they purportedly remedy. Of these, the state—or, more accurately, statism—is one of the most insidious, since worship of the state tends to supplant all other human bonds. . . ."[4]

I grew up in the 1960s and 1970s in Novato, the town where the San Francisco Police Department settled *en masse*—a recently developed bedroom community thirty miles north of San Francisco, in what was once all Coastal Miwok territory. Our own split-level ranch-style was on what was then the last frontier of suburbia; north of us were miles and miles of open space and dairy farms, and in those days before children were closely guarded we had free run of everything we could reach on foot. The hills were a refuge from my explosive family and from a hostile community of conservative adults and their unimaginative offspring, and they were a fine refuge, full of snakes, lizards, deer, trees, creeks,

berries, changes, surprises, seasons, dangers, raptures.

I was a semirural kid in a countryside with which my urban parents had no acquaintance; I roamed, learned from books and from the terrain itself, and rejoiced in an extrasocial world. The natural seemed utterly separate from the cultural in this landscape whose history no one narrated, and whose relics had all been ignored or effaced. Toward the end of my days in Novato, when my parents had split up, my father briefly dated an amateur archaeologist who told me that, in the 1950s, the biggest Indian burial mound in California had been bulldozed into flatness without being excavated, to make way for one of the shopping centers in the center of town. Suburbia has ever since then seemed to me a voluntary limbo, a condition more like sedation than exile, for exiles know what's missing. But we were on its outermost edges, and other worlds came seeping in.

Only the hot days during summer vacation seemed long enough to reach Mount Burdell, the highest point between Novato and Petaluma, a big hill around whose head oaks clustered among the grass that would always be bright, dry gold by that time. There was a spring halfway up, welling out of a little cement basin, and a quarry with all the charms dangerous plummets have for children, and scattered deer waking from their daytime slumbers to burst away in weightless leaps. Running along the top of the mountain was a long wall of stones gathered from the slopes

around (built in the nineteenth century by Chinese labor, as I read later). The wall marked the boundary of a ranch, Rancho Olompali, whose buildings at the foot of the hill faced the northern end of the bay. I saw it often and visited it once when I tagged along with my brothers' cub scout troop. Otherwise, no one mentioned the rancho in our history lessons, or mentioned that any of California's history was local and tangible. When we peered at the original adobe through the walls of the mansion that had been built around it, age itself, rather than the events that had transpired since its erection on Mexican soil, was supposed to make these mud bricks significant.

The site had originally been a Miwok village. In 1843, it was given as a land grant to a Miwok man, Camilo Ysidro, who had successfully assimilated into the Spanish lifestyle of the rancheros (and whose daughter later married a Harvard man, a gringo). There wasn't much said about the Miwok either; in those days the textbooks said that all California's Indians—speakers of more than a hundred languages, each with its own cosmology—had been primitive diggers with little culture, material or intellectual, and the same textbooks implied they had conveniently vanished in some manner as vague and uninteresting as the diggers themselves. I was an adult when I found out that Rancho Olompali was the scene of the only fatal battle in the Bear Flag Revolt of 1846. By the time I was taken there as a child it had passed into the hands of a real estate

consortium, and then on to a hippie commune called The Family. Jerry Garcia of the Grateful Dead says that he had his last acid trip there. In 1969, The Family accidentally burned the mansion down, but the adobe walls survived. Since then, the place has passed into public hands, though its significance as a war zone still goes virtually unmentioned, as does the war itself.

By 1846, it had become clear that the U.S. was going to have California one way or another. The annexa-

To be rooted is perhaps the most important and least recognized need of the human soul. —Simone Weil

tion of Texas was a prelude. There had been a few abortive raisings of the U.S. flag in California in 1844 and in March of 1846; even the Mexican military administrator of the north, General Mariano Vallejo, was prepared to hand it over peacefully. The American consul in Mexican California wrote on April 23 of 1846, "The pear is near ripe for falling."[5] How ripe the consul could not have known: the first battle against Mexico began on the Rio Grande in Texas two days later. On June 14 a group of Yankees, many of them illegally in California, began their own war by taking General Vallejo hostage at his Sonoma house, ignorant both of the war already being waged and of Vallejo's acquiescent position. The Bear Flag Revolt, named after the grizzly-bear flag they raised soon after their initial raid (still the state flag), was

something of a farce—a handful of eclectic, grimy, and often drunk Yankees chasing after the widely scattered Mexican citizens of the region. Even its instigators admitted, "We are robbers, or we *must* be conquerors!"[6]

On June 24, the insurgents attacked the Mexicans at Rancho Olompali while the latter were eating breakfast—perhaps California's first drive-by shooting—and in the resulting skirmish, one Mexican died. Long afterward, the marks of bullets were said to be visible on the old oaks and bays clustered around the house, though I have not found them. And soon after California was declared a republic the war with Mexico expanded to the Pacific front, where it dragged on until the Treaty of Guadalupe-Hidalgo in 1848. The transfer they effected still holds: California is part of the United States.

American history as it's taught and written about is preoccupied with two other trajectories that bracket the Mexican-American War: the east-west conflict of the Revolutionary War, and the bloody fraternal strife between north and south in the Civil War. Neither had much to do with the American West, which in some ways still seems like a colony of the east: one of the definitions of a colony is a place conceptualized as an outpost of a distant center, a backwater, fringe, or wilderness, a place that must look elsewhere for history and culture. Very few people look for history here, certainly not my fellow Californians who voted for Proposition 187 in the fall of 1994,

the initiative to strip immigrants of health and education rights. They seem to regard the border drawn in 1848 as eternal, meaningful, and morally if not divinely ordained, rather than the result of such unedifying events. In the light of that history, the border seems like an arbitrary line to me, as arbitrary as the lines on the 1819 map are; perhaps it's history itself that reveals how contingent, contextual, impermanent, such things are.

The same history makes it clear that it was the corruption and chaos of the Mexican government in the 1840s which made the southwest such easy pickings. And Mexico had only been independent from Spain since 1821, and before that California already had a population, the indigenous peoples who have the first and strongest claim to the land, and who were devastated by the Franciscan Missions and the rancheros before being literally decimated (but not wiped out) by the gringos in the Gold Rush. I don't know what the border means, but I know that almost no one else knows either—including the xenophobic nationalists who brought us 187. I suspect it's going to become less relevant even as it becomes more heavily guarded, our little Berlin Wall-in-the-sand dividing two countries becoming more and more alike. Within the next few decades, people whose origins lie south of that line will be the majority in California, and those of us who are children of other migrations will have become, like indigenous Americans before us, immigrants without moving. ◀

1 See Walter Benjamin's famous passage in "Theses on the Philosophy of History": "This is how one pictures the angel of history. His face is turned toward the past. Where we perceive a chain of events, he sees one single catastrophe which keeps piling wreckage upon wreckage and hurls it in front of his feet. The angel would like to stay, awaken the dead, and make whole what has been smashed. But a storm is blowing from Paradise; it has got caught in his wings with such violence that the angel can no longer close them. . . . This storm is what we call progress." (pp. 257–8 in *Illuminations*, edited and introduced by Hannah Arendt (New York: Schocken Books, 1968).
2 Salman Rushdie, *Imaginary Homelands: Essays and Criticism, 1981-1991* (Penguin Books, 1991), p. 12.
3 Cornel West, "The New Cultural Politics of Difference," in *OUT THERE: Marginalization and Contemporary Culture* (New Museum, New York/MIT Press, 1990), p. 24.
4 Edward Said, "Reflections on Exile," in *Altogether Elsewhere: Writers on Exile*, edited by Marc Robinson (Boston & London: Faber & Faber, 1994), p. 146.
5 John S. D. Eisenhower, *So Far from God: The U.S. War with Mexico, 1846–1848* (New York: Random House, 1989), p. 204
6 Neal Harlow, *California Conquered; War and Peace on the Pacific 1846-1850* (Berkeley, Calif: University of California Press, 1982), p. 103.

ARTISTS

ALBERT CHONG was born of Chinese and African descent in Kingston, Jamaica. His work has been shown in numerous group and solo exhibitions in Jamaica, and at national venues including the Museum of Modern Art, New York; Photographic Resource Center, Boston; The Walker Art Center, Minneapolis; Visual Studies Workshop, Rochester; and the Museum of Photographic Arts, San Diego. In 1994, he designed an installation for the "Open Space" series at the Ansel Adams Center for Photography, San Francisco on the occasion of the publication of *Ancestral Dialogues: The Photographs of Albert Chong* (The Friends of Photography, 1994). He is the recipient of several awards and grants including a National Endowment for the Arts Fellowship, 1991 and 1992. Chong currently lives in Colorado and is an Assistant Professor of Art at the University of Colorado at Boulder. He is represented by Porter Randall Gallery, La Jolla, California and Catherine Edelman Gallery, Chicago.

LEWIS DESOTO was born in San Bernadino, California. His work has been the subject of solo exhibitions and public projects at venues including the San Jose Museum of Art; University Art Museum, Berkeley; San Francisco Arts Commission Gallery; Headlands Center for the

Arts, Sausalito; and the California Museum of Photography, Riverside. deSoto currently lives in San Francisco and is Director of Graduate Studies, California College of Arts and Crafts, Oakland. His work is represented by the Cheryl Haines Gallery, San Francisco; the Christopher Grimes Gallery, Santa Monica; and the Nicole Klagsbrun Gallery, New York.

I.T.O. was born in Japan and has been showing his work in the United States and Canada since 1989. *Interculturism*, a solo exhibition, was on view at the Sing Tao Gallery in Toronto and the Photo Gallery in Rochester, New York, in 1990 and 1991, respectively. In 1991, he received a Fellowship from the American Photography Institute to attend the National Graduate Seminar at New York University. I.T.O. currently lives in Tokyo and teaches photography at Tamagawa University. For *Interculturism*, I.T.O. received support from Kitagawa Metal Work, Fuji, and CREATE Lab.

YOUNG KIM was born in Korea and has been exhibiting her work since 1987 at venues including the Oliver Art Center, Oakland; Queens Museum of Art, New York; and SF Camerawork, San Francisco. In 1994, she received a LACE/New Langton

Arts Artists' Project Grant and a National Endowment for the Arts/ Arts International Travel Grant for Artists; she received an American Photography Institute Fellowship in 1992. She currently lives in San Francisco and teaches at the San Francisco Art Institute and the Academy of Art College, San Francisco.

KOMAR & MELAMID, a collaborative team, is comprised of Vitaly Komar and Alexander Melamid, both born in Moscow. Komar & Melamid first collaborated in 1965 and since then have shown their work in duo and group exhibitions at international venues including the Los Angeles County Museum of Art; Victoria and Albert Museum, London; Whitney Museum of American Art, New York; Solomon R. Guggenheim Museum, New York; Documenta, Kassel, Germany; San Francisco Museum of Modern Art; and the Metropolitan Museum of Art, New York. They are credited with founding the SOTS movement, a Soviet version of Western Pop Art. In 1981, they received a grant from the National Endowment for the Arts, the first Russian artists to do so. Komar & Melamid currently live in New York City.

DINH Q. LE was born in Vietnam and since 1989 has shown his work

in group and solo shows at venues including the Bronx Museum, New York; The Art Institute of Boston; Center for Exploratory and Perceptual Art (CEPA), Buffalo; the Asian American Arts Centre, New York; and the Ansel Adams Center for Phtography, San Francisco. His public projects include *Accountability?*, a poster/ postcard project organized by Creative Time, New York. In 1994, Le received a Dupont Fellowship from the Art Institute of Boston and a National Endowment for the Arts Fellowship. He currently lives and works in Vietnam.

GAVIN LEE was born in Sacramento, California. His work has been featured in solo and group exhibitions since 1989 at venues including the Los Angeles Center for Photographic Studies; Santa Barbara Contemporary Arts Forum; and SF Camerawork, San Francisco. He received a Fellowship from Art Matters, Inc., New York in 1992, and the James D. Phelan Award in Photography from the San Francisco Foundation and SF Camerawork in 1991. Lee currently lives in Alhambra, California. He is represented by Gracie Mansion, New York.

MARÍA MARTÍNEZ-CAÑAS was born in Havana, Cuba and has been featured internationally in solo and group exhibitions since 1967 at venues including the Museum of Fine Art, University of Puerto Rico, San Juan; Center for Creative Photography, Tucson; Iturralde Gallery, Los Angeles; and Musee de la Photogra-

phie, Porte Sarrazine, France. She received a Light Work Artist-in-Residence Grant at Syracuse, New York, in 1990, a National Endowment for the Arts Artist Fellowship in Photography in 1988, and a Fulbright-Hayes Grant in 1985. She received an M.F.A. from the School of the Art Institute of Chicago in 1984, and a B.F.A. in Photography from the Philadelphia College of Art in 1982. Martínez-Cañas currently lives in Miami, Florida, and is represented by Catherine Edelman Gallery, Chicago.

RUBÉN ORTÍZ TORRES was born in Mexico City. As both a painter and photographer, he has been featured internationally in solo and group exhibitions since 1982 at venues including the Municipal Art Gallery, Los Angeles; Frankfurter Kunstverein, Frankfurt, Germany; the Institute of Contemporary Art, Boston; and the New Museum of Contemporary Art, New York. He received a Fulbright Award in 1990. Ortíz Torres currently lives in Mexico and is represented by Jan Kesner Gallery, Los Angeles.

CARRIE MAE WEEMS was born in Portland, Oregon and has been exhibiting her work nationally and abroad since 1980. In 1993, a retrospective exhibition and catalogue of her work was organized by The National Museum of Women in the Arts, Washington, D.C. Weems was featured in the 1991 Biennial Exhibition at the Whitney Museum of American Art. In 1993, Weems received The Friends of Photography's Photographer of the Year Award in acknowl-

edgment of mid-career excellence and achievement. She currently resides in Brooklyn, and is represented by P.P.O.W., New York City.

KIM YASUDA's installations have been featured in solo exhibitions at the Santa Barbara Contemporary Arts Forum; SF Camerawork, San Francisco; and the Fresno Metropolitan Museum of Art, California. In 1994, she designed an installation for the "Open Space" series at the Ansel Adams Center for Photography. In 1990, she received a National Endowment for the Arts Visual Artist Fellowship in Sculpture, and in 1994 she received a Little Tokyo Cultural Trust Fellowship, a grant from Art Matter, Inc. Foundation, and a fellowship from the Banff International Artists Residency. Yasuda currently teaches at the University of California, Santa Barbara.

ESSAYISTS

REBECCA SOLNIT is an essayist, critic, and activist whose books include *Secret Exhibition: Six California Artists of the Cold War Era* (City Lights, 1991), *Kingdoms*, a collaboration with Lewis deSoto (California Museum of Photography, 1993), and *Savage Dreams: a journey into the hidden wars of the American West* (Sierra Club Books, 1994).

RONALD TAKAKI is the Chairman of the Ethnic Studies Department at the University of California, Berkeley, and the author of six books, including *A Different Mirror: A History of Multicultural America* (Little, Brown, 1993).

ALBERT CHONG
Aunt Winnie's Story, 1994. Thermal transfer print on canvas, inscribed copper mat, 30 by 20 in. Courtesy of the artist

Jesus, Mary and the Perfect White Man, 1988-1995. Gelatin silver print, inscribed copper mat, 48 by 40 in. Courtesy of the artist

Passages and Totems, 1990–1995. Gelatin silver print, inscribed copper mat, 29½ by 37 in. Courtesy of the artist.

Story About My Father, 1994. Thermal transfer print on canvas, inscribed copper mat, 30 by 20 in. Courtesy of the artist

The Two Generations, 1990–1995. Gelatin silver print, inscribed copper mat, 48 by 40 in. Courtesy of the artist

Throne for the Gorilla Spirits, 1993. Chromogenic dye bleach print, inscribed copper mat, 40 by 50 in. Courtesy of the artist

Untitled (Throne with Crucifix, Water and Dreadlocks), 1991. Gelatin silver print, inscribed copper mat, 44½ by 36 in. Courtesy of the artist

What Will be Your Next Incarnation?, from the series *The Justice*, 1990–1994. Gelatin silver print, inscribed copper mat, 20 by 24 in. Courtesy of the artist

LEWIS deSOTO
Slover Codex, from the installation *Tahualtapa (Hill of the Ravens)*, 1987–1988. Gelatin silver print with text, 42 by 42 in. Collection of the Seattle Art Museum, gift of the artist

Slover Compass, from the installation *Tahualtapa (Hill of the Ravens)*, 1987–1988. Chromogenic prints and maps, 123 by 123 in. overall. Collection of the Seattle Art Museum, gift of the artist

Tahualtapa Statement, from the installation *Tahualtapa (Hill of the Ravens)*, 1985–1987. Lenticular color photograph and text, 20 by 16 in. Collection of the Seattle Art Museum, gift of the artist

I.T.O.
#031 Ethnocentrism II –The Revenge of Sushi, from the series *Interculturism*, 1990-1995. Mixed media installation, 37½ by 72 by 72 in. overall. Courtesy of the artist

#011 Staple, 1990–1995. Mixed media installation, 31½ by 114 by 6¾ in. overall. Courtesy of the artist

YOUNG KIM
Distances, 1992. Twelve gelatin silver prints, plywood, ink, acrylic, 22 in. by 25 ft. overall. Courtesy of the artist

KOMAR & MELAMID
Untitled, from the series *Bayonne*, 1990. Chromogenic prints, collage, 30 by 40 in. Courtesy of the artists

Untitled, from the series *Bayonne*, 1990. Chromogenic prints, collage, 30 by 40 in. Courtesy of the artists

Untitled, from the series *Bayonne*, 1990. Chromogenic prints, collage, 30 by 40 in. Courtesy of the artists

Untitled, from the series *Bayonne*, 1990. Chromogenic prints, collage, 30 by 40 in. Courtesy of the artists

Untitled, from the series *Bayonne*, 1990. Chromogenic prints, collage, 40 by 30 in. Courtesy of the artists

DINH Q. LE
Interconfined, 1994. Chromogenic prints and linen tape, 55 by 39 in. Courtesy of the artist

Self Portrait #15, from the series *Portraying a White God*, 1989. Chromogenic prints and linen tape, 40 by 30 in. Courtesy of the artist

Self Portrait After Bosch, "The Temptation of St. Anthony," 1991. Chromogenic prints and linen tape, 40 by 57 in. overall. Courtesy of the artist

Self Portrait with Angel from the Perússis Alterpiece, 1990. Chromogenic prints and linen tape, 40 by 30 in. Courtesy of the artist

GAVIN LEE
Concerning George, 1994. Digital imagery, mixed media installation, approx. 3 by 9 by 3½ ft. overall. Courtesy of the artist

Digital images, various sizes up to
10 by 8 in.:
 Identity
 Ivar Johnson
 Jade Cicada
 Koumingtang
 Ruins
 Lottery
 Red Confession
 Red Entry
 San Quentin
 SS China
 Village
 Would Be

MARÍA MARTÍNEZ-CAÑAS
*Quince Sellos Cubanos/Fifteen Cuban
Stamps*, 1991. Portfolio of 15 collaged
gelatin silver prints, 20 by 16 in.
each or the reverse, with 15 original
Cuban postage stamps, approx. 1 by
1 in. each. Courtesy of the artist
and Catherine Edelman Gallery,
Chicago

Collages (with dates of original
stamps):
 Abstraccion, Wifredo Lam, 1965
 *Centario Nacimiento General José
 Maceo*, 1952
 *Centario Primer Sello Antilles
 Españolas*, 1955
 *Centario Primer Sello Postal de las
 Americas*, 1944
 Cuba 4 Centavos, 1958
 Diario de La Marina, 1958
 Eden, 1970
 El Mantel Blanco, Amelia Peláez,
 1978
 La Quinta Column Te Espla, 1943
 Naturaleza Muerta, Amelia Pelaez,
 1967
 Navidades 1958–59, 1958
 Primavera, Jorge Arche, 1967
 Tabaco Habano, 1939
 Tabaco Habano (Azul), 1939
 Virgen de La Caridad, 1956

RUBÉN ORTÍZ TORRES
*500 Years After/500 Años Después, Valen-
cia, California*, 1992. Chromogenic
print, 20 by 24 in. Courtesy of the
artist and Jan Kesner Gallery, Los
Angeles

*Compton/Belleza Negra de Compton,
Los Angeles, California*, 1992. Chro-
mogenic print, 20 by 24 in. Courtesy
of the artist and Jan Kesner Gallery,
Los Angeles

*Ducktales/Pataoventuras, Mexico City,
Mexico*, 1991. Chromogenic print, 20
by 24 in. Courtesy of the artist and
Jan Kesner Gallery, Los Angeles

*Graceland Apparition/El Vez, Los Angeles,
California*, 1991. Chromogenic print,
20 by 24 in. Courtesy of the artist
and Jan Kesner Gallery, Los Angeles

*Made in Mexico, Rosarito, Baja Califor-
nia*, 1991. Chromogenic print, 20 by
24 in. Courtesy of the artist and Jan
Kesner Gallery, Los Angeles

*Mexican Sombreros, Los Angeles, Califor-
nia*, 1991. Chromogenic print, 20 by
24 in. Courtesy of the artist and Jan
Kesner Gallery, Los Angeles

*Santo Niño/Holy Kid, Guanajuato,
Mexico*, 1991. Chromogenic print, 24
by 20 in. Courtesy of the artist and
Jan Kesner Gallery, Los Angeles

*Venderemos/Sandino & Mickey in a
Restaurant, Mexico City, Mexico*, 1991
Chromogenic print, 20 by 24 in.
Courtesy of the artist and Jan
Kesner Gallery, Los Angeles

CARRIE MAE WEEMS
Untitled, from the series *Africa*, 1993.
3 gelatin silver prints, 60 by 20 in.

overall. Courtesy of the artist and
P.P.O.W., New York

Untitled, from the series *Africa*, 1993.
3 gelatin silver prints, 25 by 60 in.
overall. Courtesy of the artist and
P.P.O.W., New York

Untitled, from the series *Africa*, 1993.
2 gelatin silver prints, text, 25 by 60
in. overall. Courtesy of the artist and
P.P.O.W., New York

Untitled, from the series *Africa*, 1993.
Gelatin silver print, 20 by 20 in.
Courtesy of the artist and P.P.O.W.,
New York

Untitled, from the series *Africa*, 1993.
Gelatin silver print, text, 20 by 40 in.
overall. Courtesy of the artist and
P.P.O.W., New York

KIM YASUDA
She Was Both, from the installation
Hereditary Memories, 1991. Mixed
media, approx. 4 by 12 by 20 in.
overall. Courtesy of the artist

BOOKS

Abrash, Barbara, ed. *Mediating History: The MAP Guide to Independent Video By and About African American, Asian American, Latino, and Native American People.* New York: New York University Press, 1992.

Across the Pacific: Contemporary Korean and Korean American Art. New York: Queens Muscum of Art, 1993. (Exhibition Catalogue)

Archer, Nuala. *From a Mobile Home.* Galway, Ireland: Salmon Publications, Ltd., 1995.

Ashcroft, Bill, Gareth Griffiths and Helen Tiffin. *The Post-Colonial Studies Reader.* London and New York: Routledge, 1995.

Bammer, Angelika. *Displacements: Cultural Identities in Question.* Bloomington and Indianapolis: Indiana University Press, 1994.

Becker, Carol. *Different Voices: A Social, Cultural, and Historical Framework for Change in the American Art Museum.* New York: Association of Art Museum Directors, 1992.

Boyd, Alex, ed. *Guide to Multicultural Resources, 1995-96.* Fort Atkinson, Wis.: Highsmith Press, 1995.

Chermayeff, Ivan. *Ellis Island: An Illustrated History of the Immigrant Experience.* New York: Macmillan, 1991.

Chong, Albert. *Ancestral Dialogues: The Photographs of Albert Chong.* Essays by Thelma Golden and Quincy Troupe. San Francisco: The Friends of Photography, 1994.

deSoto, Lewis and Rebecca Solnit. *Kingdoms.* Riverside, Calif.: California Museum of Photography, 1993.

Enyeart, James L. *Invisible in America: An Exhibition of Photographs.* Lawrence, Kan.: University of Kansas Museum of Art, 1973. (Exhibition Catalogue)

Ferguson, Russell, Martha Gever, Trinh T. Minh-ha and Cornel West, eds. *OUT THERE: Marginalization and Contemporary Culture.* New York: New Museum/MIT Press, 1990.

Ferrer, Elizabeth. *Through the Path of Echoes: Contemporary Art in Mexico.* New York: Independent Curators Incorporated, 1990.

Gonzalez, Manuel E. *Caught Among the Cultures.* Miami: The Art Museum at Florida International University, 1993. (Exhibition Catalogue)

Jonas, Susan, ed. *Ellis Island: Echoes From a Nation's Past.* New York: Aperture Foundation, 1989.

Kirsh, Andrea and Susan Fisher Sterling. *Carrie Mae Weems.* Washington: The National Museum of Women in the Arts, 1993.

Kruger, Barbara and Phil Mariani, eds. *Remaking History.* Seattle: Bay Press, 1989.

Lee, Gavin. *Family.* Woodland Hills, Calif.: Pierce College Art Gallery, 1993. (Exhibition Catalogue)

Lippard, Lucy R. *Mixed Blessings: New Art in a Multicultural America.* New York: Pantheon Books, 1990.

Lucie-Smith, Edward. *Race, Sex, and Gender In Contemporary Art.* New York: Abrams, 1994.

Mariani, Philomena, ed. *Critical Fictions.* Seattle: Bay Press, 1991.

Merelman, Richard M. *Representing Black Culture.* New York: Routledge, 1995.

Miller, Kerby. *Emigrants and Exiles: Ireland and the Irish Exodus to North America.* New York, Oxford: Oxford University Press, 1985.

Ratcliff, Carter. *Komar & Melamid.* New York: Abbeville, 1991.

Rich, Adrienne. *Your Native Land, Your Life.* New York, London: W.W. Norton & Co., 1986.

Robinson, Marc, ed., *Altogether Elsewhere: Writers on Exile.* Boston, London: Faber & Faber, 1994.

Rodriguez, Richard. *Days of Obligation: An Argument with my Mexican Father.* New York, London: Penguin Books, 1992.

—————————. *Hunger of Memory. The Education of Richard Rodriguez: An Autobiography.* Boston: D.R. Godine, 1982.

Rushdie, Salman. *Imaginary Homelands: Essays and Criticism, 1981-1991.* New York, London: Penguin Books, 1991.

Said, Edward W. *Culture and Imperialism.* New York: Vintage Books, 1994.

Seven Contemporary Korean-American Visual Artists. Belmont, Calif.: College of Notre Dame, 1994. (Exhibition Catalogue)

Solnit, Rebecca. *Savage Dreams: A Journey into the Hidden Wars of the American West.* San Francisco: Sierra Club Books, 1994.

—————————. *Secret Exhibition: Six California Artists of the Cold War Era.* San Francisco: City Lights, 1991.

Takaki, Ronald T. *A Different Mirror: A History of Multicultural America.* Boston: Little, Brown, 1993.

—————————. *Ethnic Islands: The Emergence of Urban Chinese America.* New York: Chelsea House, 1994.

—————————. *Iron Cages: Race and Culture in 19th-Century America.* New York: Oxford University Press, 1990.

Weems, Carrie Mae. *And 22 Million Very Tired and Very Angry People.* San Francisco: San Francisco Art Institute, 1992. (Exhibition Catalogue)

Weisberg, Ruth and Pamela Zwei-Burke. *In Terms of Time.* Santa Barbara, Calif.: The Contemporary Arts Forum, 1994. (Exhibition Catalogue)

Willis-Thomas, Deborah. *An Illustrated Bio-Bibliography of Black Photographers, 1940-1988.* New York: Garland Press, 1989.

Zable, Arnold. *Ashes and Diamonds.* New York: Harcourt Brace & Company, 1994.

Ziff, Trisha, ed. *Between Worlds: Contemporary Mexican Photography.* New York: Institute of Contemporary Photography, 1990.

Cultural Resources

The following arts organizations are listed in the *Guide to Multicultural Resources, 1995-96* (Fort Atkinson, Wis.: Highsmith Press, 1995), one of the most comprehensive and useful multicultural reference directories in the United States.

African American Cultural Organizations

African American Cultural Center
350 Masten Ave.
Buffalo, N.Y. 14209
716.884.2013

ETA Creative Arts Foundation, Inc.
7558 W. Chicago Ave.
Chicago, Ill. 60619
312.752.3955

Asian American Cultural Organizations

Asian American Arts Alliance
339 Lafayette St., 3rd Floor
New York, N.Y. 10012
212.979.6734

Temari: Center for Asian and Pacific Arts
PO Box 12185
Honolulu, Hi. 96828
808.735.1860

Hispanic American Cultural Organizations

Association of Hispanic Arts
173 E. 116th St., 2nd Fl.
New York, N.Y. 10029
212.860.5445

INTAR Hispanic American Arts Center
PO Box 788
New York, N.Y. 10108
212.695.6135

Native American Cultural Organizations

American Indian Inter-Tribal Cultural Organization, Inc.
PO Box 775
Twinbrook Station
Rockville, Md. 20848
301.869.9381

Atatl, The National Service Organization for Native American Art
2302 N. Central Ave., Ste. 104
Phoenix, Ariz. 85004
602.253.2731

Aproject of this scope is not the work of a single imagination but, like culture itself, a complex construction of many narratives, ideas, arguments and points of view. Many individuals and communities played formative roles in the development of *Tracing Cultures*, and while any shortcomings in the initial impulse and final result can rightly be attributed to myself, I am immensely grateful to all those who offered advice and dissent along the way.

The artists of *Tracing Cultures* deserve primary credit, not only for the flesh of the exhibition but also for its bones. The force and vitality of their work was the impetus for the exhibition; without them, the idea for a show of contemporary photographic work about cultural displacement would have been an embarrassment without riches. Remarkably, their work is only representative of contemporary art in this vein, and I could well have added a dozen more artists to the roster without compromising the result.

The staff of the Ansel Adams Center for Photography, the San Francisco museum of The Friends of Photography, shaped and kneaded the show from its origins more than three years ago through its national tour. Programs Coordinator Allyson Nolte oversaw the collection of the artwork and worked with the artists to assemble the checklist, assisted by Charlene Rule. Deborah Klochko, Deputy Director for Public Programs, oversaw the development of a broad range of programs to enhance the exhibition, with the primary assistance of Julia Brashares and Katherine Whitney. Two consecutive Development Directors, Margie Shackelford and Barbara Alvarez, saw to securing much-needed support for the show, and Carrie Mahan ably oversaw publicity. Administrative headaches were cured by Lisa Robb, Pam Allen, Winona Reyes, and the rest of our dedicated staff.

Our partners in the larger project, POINTS OF ENTRY, contributed greatly to the unfolding of *Tracing Cultures*. Arthur Ollman, Director of the Museum of Photographic Arts, and Terence Pitts, Director of the Center for Creative Photography, were especially helpful in suggesting artists and sources. Among the many others who assisted in the search for fresh and underappreciated work were Linda Connor, Lewis deSoto, and Reagan Louie.

The assistance of galleries and museums was invaluable in bringing the show to fruition. Special thanks are bestowed to Jan Kesner of the Jan

Kesner Gallery, Los Angeles; Catherine Edelman of the Catherine Edelman Gallery, Chicago; Ed Yankov of the Komar & Melamid Studio, New York; Ronald Feldman Gallery, New York; and P.P.O.W., New York. Rod Slemmons, curator of photography at the Seattle Art Museum, helped immensely with advice and loan assistance.

This catalogue of *Tracing Cultures* is the product of the fortitude and talent of Michael Read, Editor of The Friends of Photography's publications, and Steven Jenkins, The Friends' Associate Editor, working together with Rupert Jenkins, who ably served as Production Editor. Michiko Toki once again demonstrated her unique talent in designing the publication and making it a work of art itself. The New Lab in San Francisco generously helped us with slide processing for publicity and reproduction.

Rebecca Solnit has written an autobiographical essay of enviable depth, complexity, and coherence, on demand and in short order; my admiration for her writing is coupled with great respect for her thinking. Scholar Ronald Takaki's essay cogently makes clear the historical imperatives behind the work featured here. In addition, I want to acknowledge the impact that Richard Rodriguez's writings have had on my own thinking as the exhibition was taking shape. In today's highly politicized debate about immigration, one thing seems clear: there is no agreed-upon standard of cultural opinion because every voice speaks from an individual and historical position within culture.

Finally, The Friends of Photography owes an enormous debt of gratitude to AT&T's "New Art/New Visions" program for its early and crucial sponsorship of *Tracing Cultures*. Suzanne M. Sato of the Arts & Culture Program in New York and Ross Markwardt, Alan Scott, and Susan Watson in San Francisco were especially helpful and enthusiastic about the show in its early stages; I hope their enlightened approach to support of the arts continues to be a beacon for others. Without AT&T's support, *Tracing Cultures* would not be the challenging, thought-provoking exhibition that it has become.

Andy Grundberg
Director
The Friends of Photography

6385